**Mr. Theodore Cohn**
923 5th Avenue
New York, NY 10021

# BESA

## MUSLIMS WHO SAVED JEWS
## IN WORLD WAR II

# BESA

## MUSLIMS WHO SAVED JEWS
## IN WORLD WAR II

• • •

## NORMAN H. GERSHMAN

Syracuse University Press

Copyright © 2008 by Syracuse University Press

Syracuse, New York 13244-5160

First Edition 2008

08  09  10  11  12  13      6  5  4  3  2  1

All photographs courtesy of the author.

The paper used in this publication meets the minimum requirements of
American National Standard for Information Sciences—Permanence of
Paper for Printed Library Materials, ANSI Z39.48–1984.∞™

For a listing of books published and distributed by Syracuse University Press,
visit our Web site at SyracuseUniversityPress.syr.edu

ISBN-13: 978-0-8156-0934-6
ISBN-10: 0-8156-0934-5

Library of Congress Cataloging-in-Publication Data
Gershman, Norman H.
Besa : Muslims who saved Jews in World War II / Norman H. Gershman. —1st ed.
p. cm.
ISBN 978-0-8156-0934-6 (hardcover : alk. paper)
1. Righteous Gentiles in the Holocaust—Albania.   2. World War, 1939–1945—Jews—
Rescue—Albania.   3. Jews—Albania—History—20th century.   4. Holocaust, Jewish
(1939–1945)—Albania.   5. Albania—Ethnic relations. I. Title.
D804.65.G44 2008
940.53'183509224965—dc22
2008026907

*Printed in Canada*

*To the memory of Cornell Capa*

*1918–2008*

# Donors

# Contents

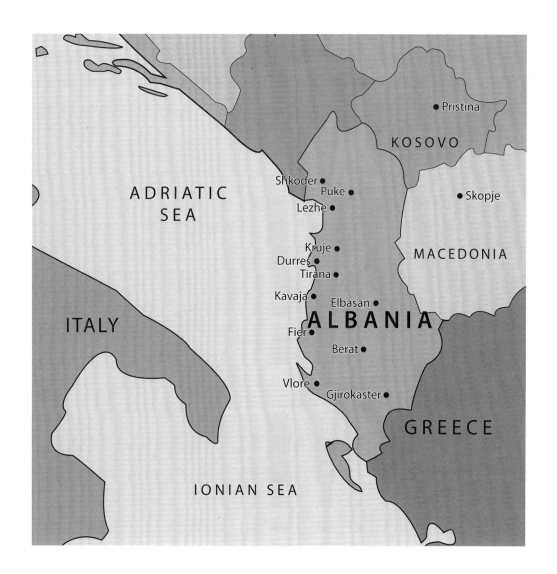

*Albania and Kosovo.*

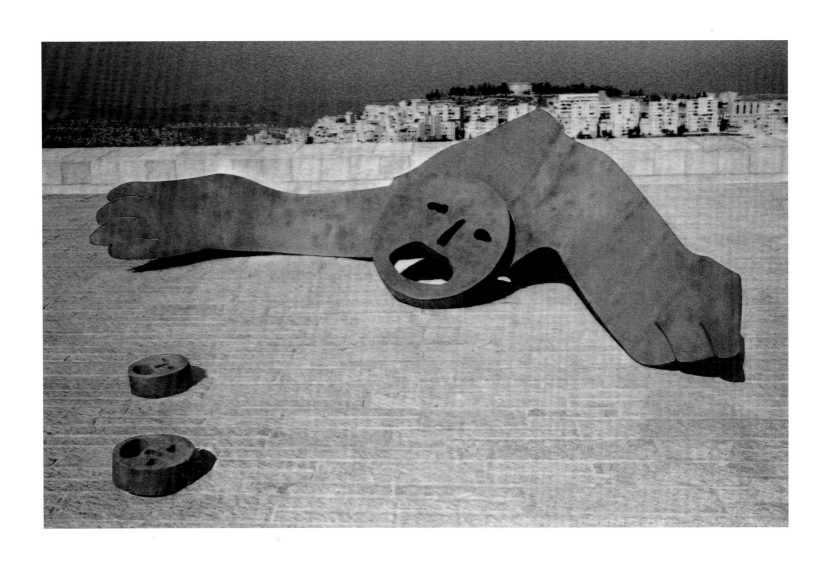

*Sculpture at Yad Vashem.*

# *Foreword*

## Mordecai Paldiel

YAD VASHEM, the Jerusalem-based Holocaust memorial, honors more than twenty-two thousand non-Jewish rescuers of Jews during the Holocaust as Righteous Among the Nations. Of these, most are Christians. Also included, however, is a small contingent of Muslim rescuers from Albania and nearby regions.

The significance of their deeds transcends the relatively small number of these rescuers, some sixty-five Righteous from Albania alone, who acted to save Jews during the German occupation of that country in 1943–44. As elsewhere during World War II, Jews in Albania were especially targeted for destruction by the ruling Germans. But their fate there was altered by an ancient and sacrosanct Albanian principle known as Besa—one's word of honor. In Albania, when a person gives you his Besa to act in a certain way, then he is committed to abide by it whatever the circumstances. This was coupled with another inherently Albanian folk principle—that of giving refuge to someone in need of help. As a result, nearly all of the two thousand–odd Jews in Albania were spared the furnaces of Auschwitz, for they were hidden or otherwise sheltered by the broad masses of a mostly Muslim population. Survivors relate that Albanians vied with each other for the honor of sheltering the fleeing Jews, a phenomenon unheard of in other European countries under the heel of the Nazis. This Islamic behavior of compassion and mercy celebrates the sanctity of life and a view of the other, the stranger, as indeed one's own close family member. Ironically, their story remained unknown for many years because of the rigid, decades' long Communist regime in that country, which forbade any contacts with outsiders; the tale of the rescue of Albania's Jews has only recently come to the fore.

So when photographer Norman H. Gershman first stepped into my office at Yad Vashem several years ago, and spoke to me of his wish to take professional photos of the Righteous living in various European countries, I directed his attention to Albania and its rescuers. His several visits there, and his encounters with the goodly nature of these inhabitants, has had a profound impact on Norman. He is a changed man, and his book is a testimony to the faith and commitment of these rescuers to the values of humanity, as well as to his determination to bring the message of these heretofore unknown rescuers to the attention of the public at large. He has since enlarged his initial investigation of wartime rescues within Albania to include rescues during the same period in nearby Kosovo, a region still troubled by internecine warfare and claiming a sizable Muslim population. It is to be hoped that Gershman's record of the faces and stories of these simple people with hearts of

gold will serve to inspire future generations, reminding them of the potential for goodness inherent in all men and providing role models for action in other troubled times. Norman H. Gershman's clear and moving photographs of these knights of the spirit, presented together with their personal recollections of their deeds, should be viewed and read by all persons who care about the future course of humanity.

Director of Special Projects                                                    January 2008
The International Raoul Wallenberg Foundation

# Introduction

## Akbar Ahmed

IN RESCUING from the dustbin of history this story of Muslims saving Jews during the dark days of the Nazi occupation of Albania, Norman H. Gershman has fostered dialogue and understanding between Jews and Muslims. Along with Christianity, Judaism and Islam constitute the three "Abrahamic" religions—that is, religions descended from the prophet Abraham. The commonality of many of their basic values is a message that is sorely needed today.

Through this book, Norman, a fine art photographer, has stepped outside the traditional role of photojournalist and become a historian with the ability and means to bring together two faiths in a time of heightened contention. His skills as a humanistic photographer and documentarian are exemplified here as his lens captures the soulful intent of these Albanian families. We may be learning about these acts of heroism only now, but the work of Norman H. Gershman and others will ensure that their story will be told for generations.

This book is more than simply a collection of pictures. To create it, Norman journeyed to Albania many times. He spoke with the people involved and recorded their stories and those of their children. He took photos of them as they appear today, photos that, when melded with the stories and artifacts from the past Gershman collected, present an emotional and unprecedented window into a forgotten period in history. As an anthropologist I know the benefits of ethnography, of speaking with people in order to understand their histories and cultures. This is what Norman has magnificently accomplished in this book.

Norman has also shed light on the true nature of Islam as both a compassionate and an Abrahamic religion. For these Albanian Muslims, saving Jews was a religious calling because of the close bond between Jews and Muslims in Islam. By saving Jews, they were being good Muslims. The deep bonds that bind Islam and Judaism, together with those binding both to Christianity, the third point in the Abrahamic triangle, need to be recognized and discussed.

We are often guilty of looking at our own faith in juxtaposition, or in opposition, to the other faiths and assuming exclusivity. "We are the purest, the best," we too often tell ourselves. For me, as an anthropologist, that assumption is a myth, because there is so much osmosis, synthesis, and overlap among the faiths. Indeed, Islam consciously declares itself an Abrahamic faith and absorbs the Abrahamic legacy: notions of the divine, monotheistic, omnipotent, and invisible; the Ten Commandments; many dietary laws; the great prophets—all these elements reflect the inherited Abrahamic tradition. Abraham himself is so important to Muslims that he is mentioned five times a day,

in every prayer. The most sacred site of the Muslims, the Kabbah in Mecca, is closely associated with Abraham. The holy prophet of Islam, peace be upon him, was proud to declare his descent from Abraham.

Norman takes us into a humane, accepting Muslim society. His interview with Baba Haxhi Reshat Bardhi, the world head of the Albanian Bektashi sect, reflects this compassion and humanism in Islam. "We Bektashi see God everywhere, in everyone," the leader explained. "God is in every pore and every cell. Therefore all are God's children. There cannot be infidels. There cannot be discrimination. If one sees a good face one is seeing the face of God. 'God is beauty. Beauty is God. There is no God but God.'"

This is a time of challenge, yes, but also a time of opportunity. Many initiatives have been taken that are groundbreaking within the history of the Abrahamic traditions, Norman's book being an excellent and recent example. We must acknowledge that the way forward is through dialogue; we must recognize the urgency of the task. A sustained, holistic effort is vital: short-term measures, superficial measures, just will just not do any more.

I see Norman's book as a wonderful tool in this effort to promote dialogue and understanding within the Abrahamic religions. I am hopeful that his extraordinary achievement will be read and discussed by Jews, Muslims, and Christians.

Norman's study of the Albanian example here is testimony to an Islamic type of behavior utterly different from those so unfortunately making the headlines these days. It is a record of acts, not of vengeance, hatred, and suicide, but of compassion, kindness, and help to persons of another faith and origin. I hope that the example of the Albanian rescuers will serve as a role model inspiring others, Muslims and followers of other faiths, to walk in their footsteps and be truly human beings when faced with similar moral challenges. We all have an obligation to remember not only the evil perpetrated during the Holocaust, but also the goodness displayed by non-Jewish rescuers extending a helping hand to Jews in distress.

We as a world civilization are at the crossroads. Building these bridges across religions and cultures is no longer an intellectual pastime; it is an imperative if we are to survive the twenty-first century. The transcendent humanity Norman H. Gershman has recorded in the faces and stories of this book provide a profoundly inspiring message of hope and compassion in these days of conflict and confrontation, and I hope that it will be widely read. The spirit of Norman's book and the initiatives taken are the same: to go out, to journey, to heal a fractured world, to create learning, to listen, to have dialogue, and ultimately to create understanding.

Ibn Khaldun Chair of Islamic Studies
American University, Washington, D.C.

To the Society of the Friendship between Albania
and Israel.

### TIRANA

Shaban Zenel Kuqi,whose signiture this application bears,is from the village of Mamurras,Kruja district,inhabitant of Tirana at this address:Rruga "Bajram Curri",Pall.487,Shk.3,would like to present you the following:

In September,1943,appointed by the Health Beaurou in Tirana,a man whose firs name is Validgi,(I can't remember his family name),who was from Israel comes to our village to work as a doctor.Accompanying him was also his family,consisting of 6 members:his wife called Garufa,his 5-year-old son Drago,his wife's father Deda,who was at the age of70, his wife's mother and his wife's sister,Jelica,16 years old.

Being persecuted by the Germans,may be their names have changed,so that thye could escape them.

As soon as he got to Mamurras,he came to see my father,Zenel Kuqi, with a recomandation paper.My father,at that time,had a hotel-restaurant there.

The restaurant being in the main road,my father could not give them shelter there,but took them home.He gave them two rooms and a kitchen,part of their house,which they willingly granted.

With the help of my father,he could exercise there his medical profession in tranquility,thus coming to the aid of the peasants of that region.As a doctor he was an efficient and humanitarian one,something which made him respectable and very near to them.

Staying at our's for nearly 18 months,in the October of 1944,under the care of my father who recomended him the village of Skurraj,he left for Milot near which this village is situated,and found refuge at the church of that village.Validgi asked this from us,because at that time, the German movement was becoming allthe more ferocious,and he feared reprisals were going to take place.

There,after 20 days he was wounded by the reaction which controlled that zone;at hearing this,my father sent me immediately.I took him into my car and sent him to Tirana together with his family,at the time of a very cruel reaction.

After he was cured,he left the hospital and found  shelter in Tirana,because it was impossible to come to Mamurras,since the war to liberate Tirana had just begaun.

Even when they came to Tirana,we were in contact.Then at the beginning of 1945 they left for Beograde.

Since then we have no notice from him.

Since I did not know their real name and surname,I did not look for him,at the same time thinking that for the sake of our friendship, as a sign of gratitude,he would be the one to find us.But we have had no letter from him,nor any other notice,making use of the Association of Friendship between Albania and Israel,just set up,I'd like that you help me to find them.

Excuse me for the trouble I am causing to you,but in case a delegation comes from there,I'd like you to consider the possibility of helping me in this respect.

I remain respectfully yours,
(Shaban Zenel Kuqi)

My address is this:
Rruga"Bajram Curri"
Pall;487,Shk.1,Ap.3.
Tirana,April,1991.

*Letter from Shaban Zenel Kuqi seeking information about the Jewish family he and his father sheltered.*

# Preface

MANY PEOPLE have asked me why, sixty years after the event, I am seeking out Albanian Muslims who saved Jews during World War II.

I was born in New Jersey in 1932, far from the dangers of rising Nazism in Central Europe. As a child I listened intently to my radio, learning of the growing threat of war and the subsequent events of World War II. I remember my mother insisting that I eat my meals with consciousness of the starving Jews in Europe. The war in Europe and the eventual knowledge of the Holocaust became the defining events of my worldview, the background against which my life as a secular American Jew continually unfolds.

My photographic pilgrimages have taken me to the former Soviet Union, to the ruins of Auschwitz and the Warsaw Ghetto, and, most recently, to Albania and Kosovo. In my work with the Albanian and ethnic Albanian Muslims, who gladly opened their homes to thousands of Jews fleeing the Nazis, I have taken it upon myself to travel as an ambassador of sorts. As a Jew, and on behalf of the Jewish people, after every photographic session I have thanked each family for their rescue of Jews during the Holocaust.

Portrait photography is my way of understanding and of offering to others my innate belief in the goodness and the oneness of humanity—qualities that cross the boundaries of all races, religions, and nations.

Finally, a note on my use of the Albanian language. I used English versions of placenames and spelling for ease of reading.

Norman H. Gershman

# Acknowledgments

THIS BOOK could never have come to fruition without the various contributions of the following individuals and organizations, to whom I am deeply grateful:

Mordecai Paldiel

Stuart Huck

The Albanian-Israeli Friendship Association, notably President Petrit Zorba, Professor Apostal Kotani, and Henrik Prendushi

The Kosovo-Israeli Friendship Association, notably President Mustafa Rezniqi and Xhangyle Ilijazi

The Israeli-Albanian Friendship Association, notably Felicita Jakoel and Gavra Mandil

Yad Vashem

Altin Qeleshi

Albina Lekgjonaj

Lindsay Herlinger, Studio 101 Digital Printing

Steve Kaufman

Randi Winter

Virginia Harlow

Marci Kaplan Marchand

Larkin Eilek

Akbar Ahmed

Syracuse University Press

# BESA

## MUSLIMS WHO SAVED JEWS
## IN WORLD WAR II

# Family of Destan and Lime Balla

I WAS BORN IN 1910. In 1943, at the time of Ramadan, seventeen people came to our village of Shengjergj from Tirana. They were all escaping from the Germans. At first I didn't know they were Jews. We divided them among the villagers. My family took in three brothers by the name of Lazar. We were poor—we didn't even have a dining table—but we never allowed them to pay for the food and shelter. I went into the forest to chop wood and haul water. We grew vegetables in our garden so we all had plenty to eat. The Jews were sheltered in our village for fifteen months. We dressed them all as farmers, like us. Even the local police knew that the villagers were sheltering Jews. I remember they spoke many different languages.

In December 1945, the Jews left for Pristina, Kosovo, where a nephew of ours, who was a partisan, helped them. After that we lost all contact with the Lazar brothers. It was not until 1990, forty-five years later, that Schlomo and Mordacai Lazar made contact with us from Israel.

All of us villagers were Muslims. We were sheltering God's children under our Besa.

<div align="right">Lime Balla</div>

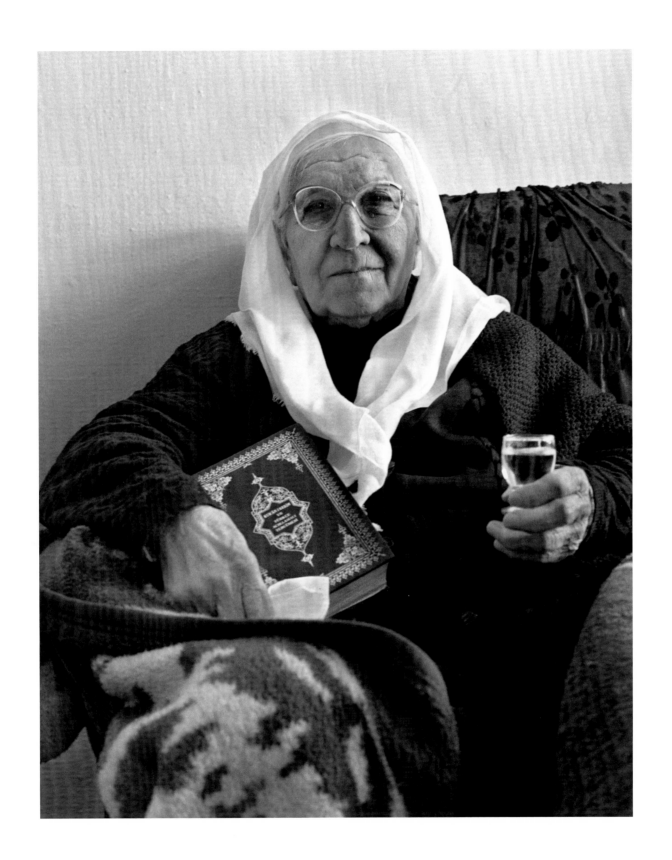

*Lime Balla.*

# Baba Haxhi Dede Reshat Bardhi

FOR FIFTEEN YEARS I have been the head of the worldwide movement of Bektashi. There are more than seven million Bektashi in the world, some even in the United States. Our sect derives from the Shia. We trace our heritage back to Imam Ali, the son-in-law of the prophet Mohammed.

We are the most liberal of Muslims. Our religious practices are conducted in the language of the country where we live. Many of our rituals are secret. In the early 1920s, Atatürk expelled our order from Turkey because we refused to remove our religious garb in public. It was then that we moved our center here to Tirana. All around us is the color green. This has been the color of our mosques for eight hundred years. Green is pure, peaceful, and clean. It is the color of the earth.

At the time of the Nazi occupation the prime minister of Albania was Medi Frasheri. He was a member of the Bektashi. He refused to release the names of Jews to the Nazi occupiers. He organized an underground of all Bektashi to shelter all the Jews, both citizens and refugees. At that time nearly half of all Muslims in Albania were Bektashi. Prime Minister Frasheri gave a secret order: "All Jewish children will sleep with your children, all will eat the same food, all will live as one family."

We Bektashi see God everywhere, in everyone. God is in every pore and every cell, therefore all are God's children. There cannot be infidels. There cannot be discrimination. If one sees a good face one is seeing the face of God.

God is Beauty. Beauty is God. There is no God but God.

Haxhi Dede Reshat Bardhi

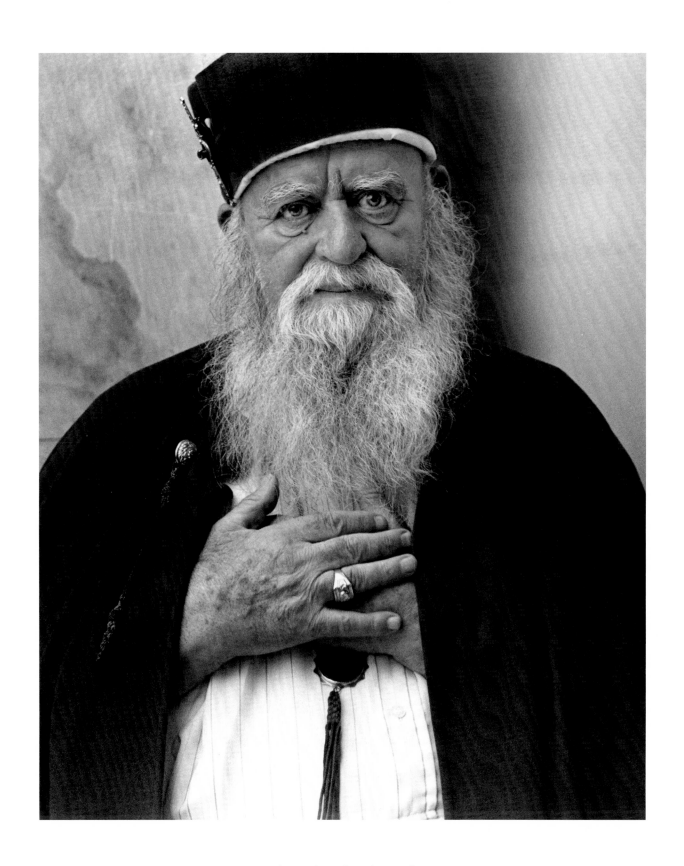

*Baba Haxhi Dede Reshat Bardhi.*

# Family of King Zog of Albania

I AM THE SON of King Zog and Queen Geraldine. My father was the first and only Muslim king of a European nation. I was born in 1939, the year that Mussolini's fascists invaded our country. I lived sixty-three years in exile in Egypt, England, and France. In 2002, I returned to Albania with my immediate family, including my son, Prince Inheritor Leka.

My father knew that the Nazis were carrying out inhuman acts as early as the 1930s. He had many Jewish friends in Vienna, in particular the Weitzman family. The Weitzmans were photographers to the elite and royalty of Europe. A beautiful picture of my father and mother, taken by the Weitzman studio, hung in all classrooms and public places throughout Albania.

At the time of Kristallnacht in 1938, my father issued four hundred passports to Jews, mainly from Vienna. These included the Oestereicher family, jewelers who designed the crown jewels for our royal family, and thirteen members of the Weitzman family. My father was even instrumental in rescuing a member of the Weitzman family from a German concentration camp. All were welcomed to Albania. When the Italians invaded my country in 1939, they gave the Jews one year to leave, so they scattered to many countries. My father told me that he chanced to meet the Oestereicher family again in London after their flight from Albania. They were destitute and asked my father for help. My father gave them back the very same crown jewels they had made for our family in Vienna.

Since returning to my country I have yet to be accepted as king. The years of foreign occupation, godless communism, and now the secular democracy have stripped my country of its royal culture. I am not well, and it is my dream that my son, Prince Inheritor Leka, will someday be returned as royal ruler of our once-proud nation.

<div style="text-align: right">King Leka I</div>

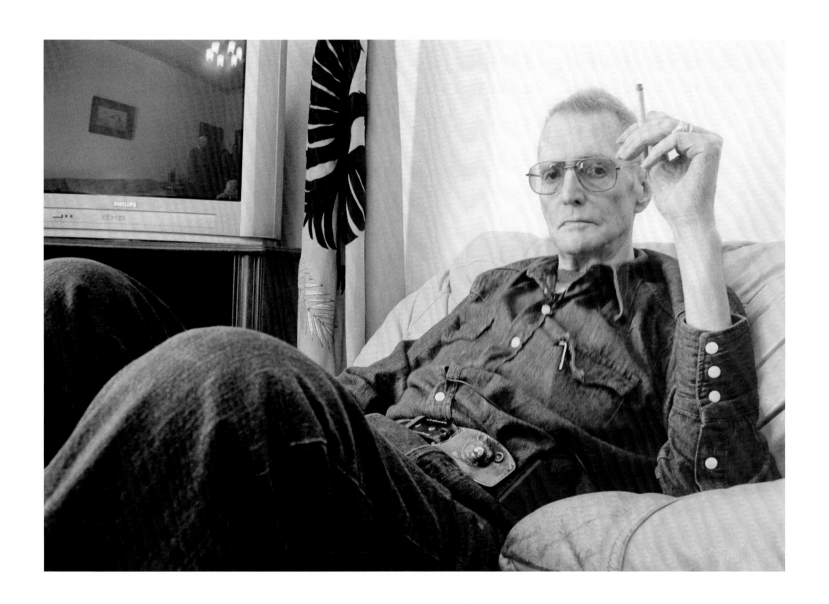

*King Leka I.*

# Family of Njazi and Liza Pilku

MY BROTHER AND I were young boys during the war. My father, Njazi Pilku, was a devout Muslim who had designed mosques here in Albania.

In 1942, my parents sheltered a Jewish family in our home in Durres, hiding them for almost four years between there and our seaside home. They were the Gerechters—father, mother, and daughter—from Hamburg, Germany. They had sought asylum in Albania after the Kristallnacht. They had been interned by the Italians, and later were arrested several times by Albanian collaborators, before they were rescued by my father.

My mother, Liza Pilku, was German, so the Nazis often visited our seaside home. We introduced the Gerechter family as our relatives from Germany. Naturally, they were terrified.

Once, in Durres, the Gestapo cordoned off the streets and searched with dogs for Jews. My mother came out of her house and scolded the Gestapo in German. She told them never to come back, to remember that she was German, too. The Gestapo left.

After the war we lost all trace of the Gerechters. The communists took power and forbade contact with anyone from the outside world. My father was arrested in 1944. In 1945, the communists killed him. Our seaside home was confiscated.

Since the fall of the communists we have made contact with the Gerechters' daughter, now Johanna Neumann, who lives in America. Johanna gave written testimony of her family's rescue, and my parents were recognized by Yad Vashem as Righteous Among the Nations.

Edip Pilku

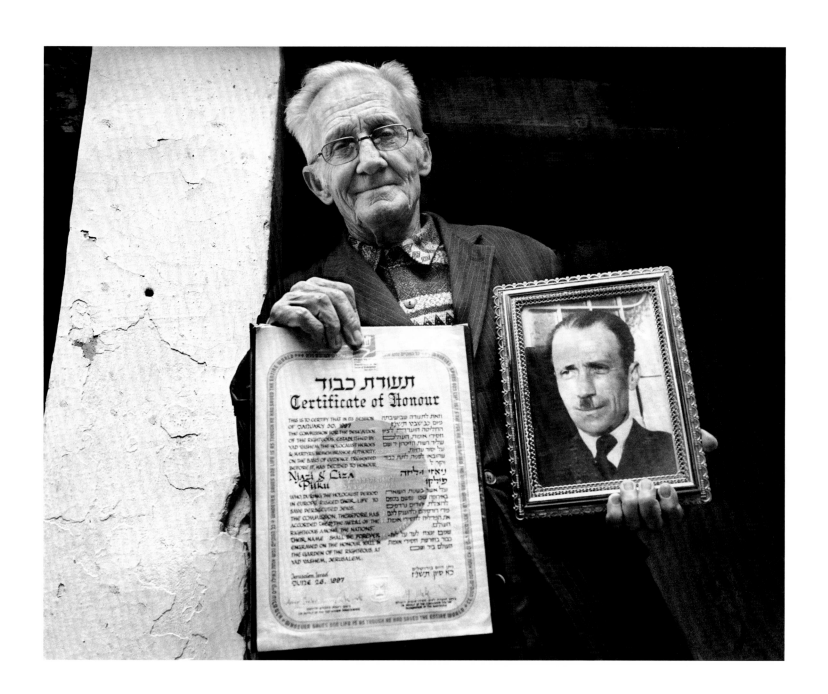

*Edip Pilku, holding picture of his father, Njazi Pilku, and certificate honoring Njazi as Righteous Among the Nations.*

# Family of Njazi Mefail Bicaku and His Son Njazi

WHEN THE ITALIANS capitulated in 1943 and the Germans moved in, my father, Njazi, was only twelve years old. His father, Njazi Mefail Bicaku—my grandfather—owned a shop in Tirana. My grandfather and father led twenty-six terrified Jews out of Tirana. They traveled twelve hours on horseback to the village of Qarrishta. My father walked barefoot.

The Jews were hidden in a large barn in the hills near the village. There were doctors, dentists, and many other professionals, and their wives and children. They called my grandfather "Father God." He would travel regularly from Tirana with food and provisions, while my father guarded the barn with a gun. They sheltered the Jews for two and a half years.

After a while the village townspeople became fearful that the Germans would discover the Jews hidden in the hills and they wanted the Jews to leave, so my grandfather and father left the village to live with the Jews in the mountains. In 1945, my grandfather and father walked the Jews to the border, and they left for Yugoslavia. From there, in the 1960s, the Jews departed to many countries—Argentina, Italy, Israel. Then we lost contact with them.

After the war the communists imprisoned my grandfather for three years. I remember him as a devout Muslim. He wouldn't have hurt a fly. My father, who is still alive, is a secular Muslim. He says: "Only trust in God, not even in the imam."

Elida Bicaku

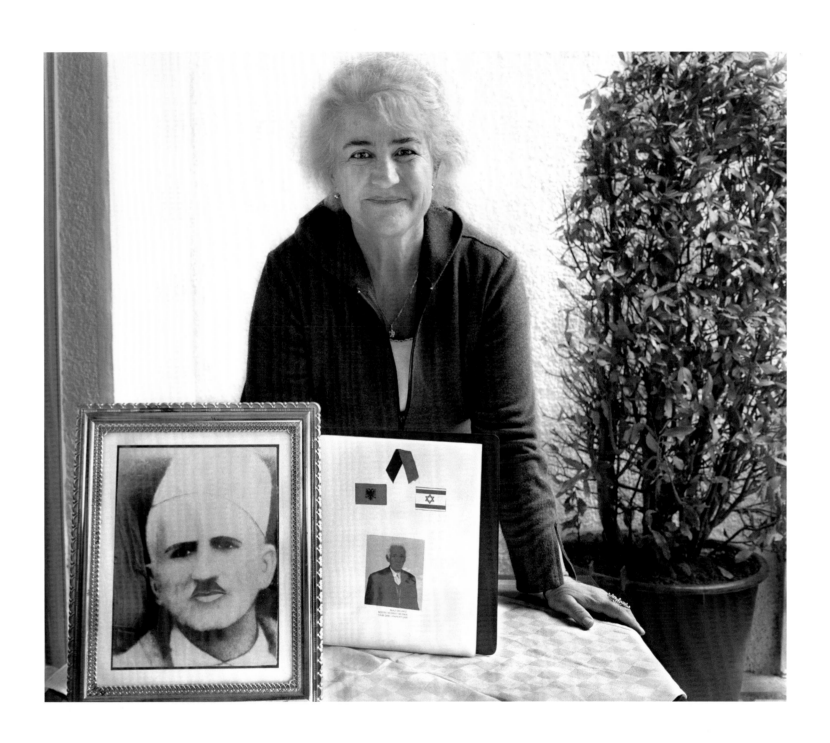

*Elida Bicaku with photographs of her grandfather, Njazi Mefail Bicaku, left, and her father, Njazi.*

# Family of Hysen Marika

I AM the daughter-in-law of Hysen Marika. In the last years of his long life I took care of him. He told me so many stories. I know them so well. I know them better than he did! Hysen owned a well-known dairy in Tirana. All the milk bottles and dairy wrappings had the Marika name on the labels. I am holding a Marika brand bottle from those days of the Marika dairy. It still holds the milk.

Hysen traveled a lot on business. In Skopje, Macedonia, he met a Jewish family who feared the Nazi occupation. Originally the family was from Bulgaria. The husband, Kajfaz, implored Hysen to shelter his wife, Bella, his sister-in-law, Alisa, and son, Jak, in Albania, which he did. They lived as one family in Hysen's home in Tirana for two years. Even Hysen's wife didn't know at first that this was a Jewish family. They were just "friends" from Macedonia. The neighbors never knew their true identity.

There were times in Tirana when the Germans were searching from house to house looking for partisans and Jews. Hysen often had to move the family to safe houses and then back to Tirana. On one occasion, the Albanian police searched his house and confiscated a briefcase belonging to the Jewish family. At the time the children were playing outside in the courtyard with a bicycle belonging to the Jewish family. The bicycle tubing was filled with gold coins and precious jewels. Hysen went to police headquarters and demanded the return of the briefcase, saying that it was under his Besa. The Albanian police honored his Besa and returned the briefcase unopened.

In January 1945, the family traveled to Shkoder dressed as Albanian peasants and were reunited with Kajfaz. We have many pictures and letters from them. Now only Jac is alive. He lives in Israel and I have his telephone number.

Hysen was not a religious man, but he did trust in God. Hysen gave his word. He gave his Besa.

Aferdita Marika

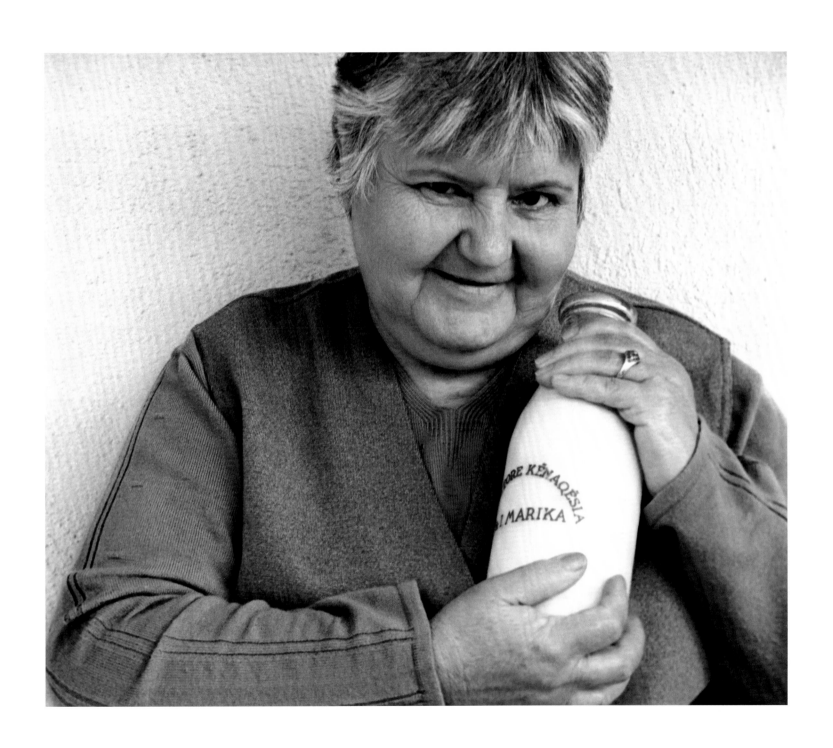

*Aferdita Marika, holding Marika dairy milk bottle.*

# Family of Jani Koca

BEFORE THE WAR our father was in business with Isak Ilbesha. They purchased cloth from England and made custom clothing in Tirana. It was a good business with many employees. Under the Italian occupation our father's Jewish partner, Isak Ilbesha, worked and lived with his family with no problems, but this changed when the Nazis moved into Tirana in September 1943. At that time we had a large garden and two houses secluded from the neighbors. We sheltered Isak, his daughter, son, and elderly mother from 1943 into 1944, in the house next door to ours. The situation became dangerous when Nazi dragnets searched the neighborhood looking for Jews. Isak left with his children for Vlore, and the grandmother moved into our home and stayed for a year, until the end of the war. Our neighbors didn't know we were sheltering anyone.

After the war Isak and his family moved to Italy. Our father received a letter from him offering to come back to Tirana to resume their business. This was the time of the communist repression, and our father was terrified even to respond to Isak. We lost all contact with the Ilbesha family.

We also sheltered a second German Jewish family—a husband, wife, and son from Ljubljana, Slovenia—for eight months. They had escaped from confinement in Pristina, Kosovo. A courier friend of our father brought them to us. Unfortunately the family left for Pristina in early 1944, and we heard that the Nazis captured them. We only remember the name of the son, Raul. The father was an old man, a physician.

Later we sheltered a third Jewish family who were close friends of our father. We have forgotten their names.

We Albanians respect foreigners even more than Albanians and honor friends in need. Our brother, Mihal, is a national hero. He was killed by the Nazis in a massacre in the streets of Tirana. We lost everything under the communists—our business, our property, our valuables.

Filip Koca
Eftarea Koca
Stavas Koca

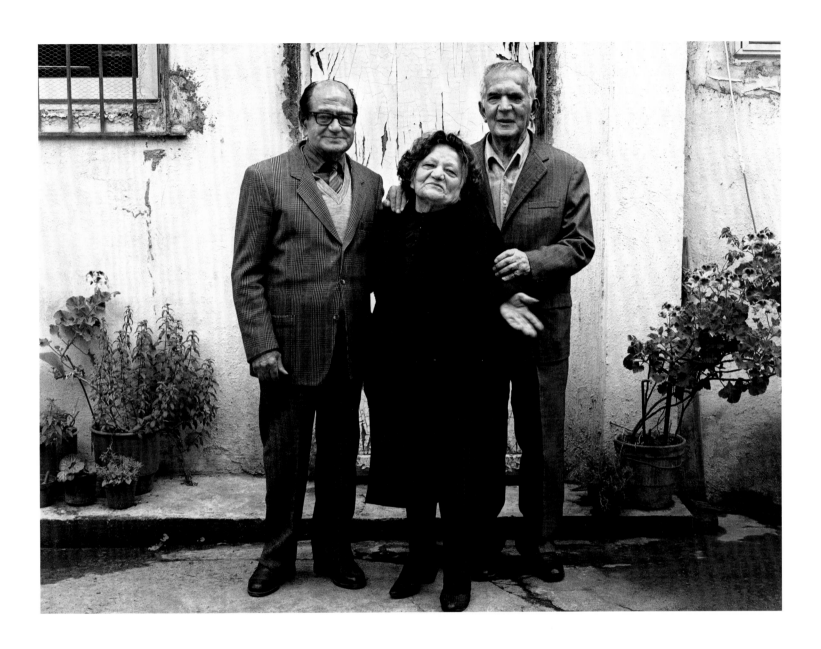

*Filip, Eftarea, and Stavas Koca.*

# Family of Islam Proseku

WE LIVED in an old house near the railroad station in Tirana. A friend of my husband asked him to help three Jews. They were all strangers to us. We took them in. We hid them in our home for one year. I remember that one owned a factory in Macedonia. I do not remember the names of those we saved. I remember how frightened they were of being denounced. I was never afraid.

My husband worked at Radio Tirana. When the Germans were preparing to evacuate Tirana they wanted to destroy the radio station. Before they could do it, my husband saved the archives and recordings.

Why did we do it? We saw the Jews as brothers. As religious but liberal Muslims, we were only doing our duty. Now my grandson is an evangelical Christian. This is fine with my son and me. There is only one God.

Nadire Proseku

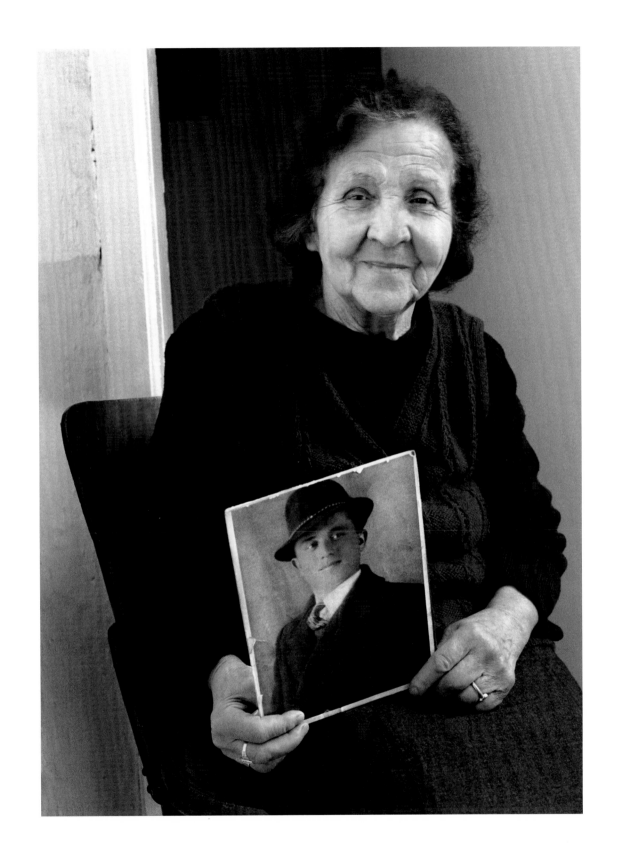

*Nadire Proseku, holding photograph of her husband, Islam.*

# Domi Family

IN OUR CITY of Elbasan, our father was very well known. He was a provisions trader and also the secretary of the Muslim Committee of Elbasan. Our parents were friendly with the Kurmaqu family. Collaboratively, our two families sheltered six Jews from the Germans. They were Raphael Cambi, the Leon Isaac family, and Chaim Isaac.

We were very young, ages ten and three, when we sheltered Jews.

Our parents were devout Muslims. They never saw any division among Muslims, Christians, and Jews.

Here are pictures of our parents. It is important that the youth of our family know what their grandparents risked in those years of German occupation.

Xhevnt Domi
Sami Domi

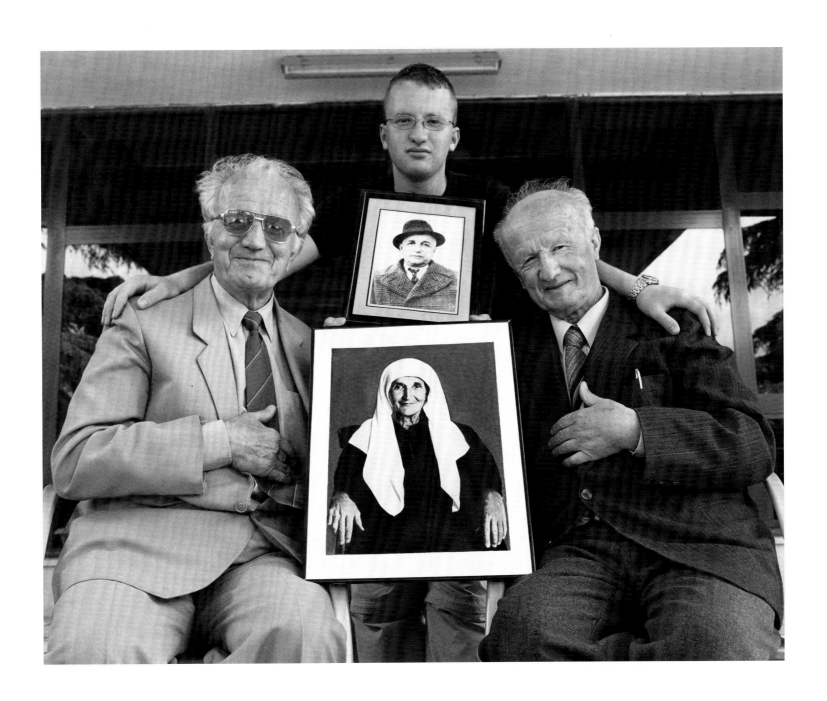

*Xhevnt and Sami Domi (seated), with grandson, holding photographs of their parents.*

# Family of Halil Frasheri

WE WERE YOUNG MEN when we aided our father in sheltering partisans, and later Jews, in our town of Berat. Our house was used as a staging area and a way station for many partisans, and came under the surveillance of the Italian fascists.

Our father's best friend implored him to shelter fourteen members of three Jewish families who were literally on the streets fleeing the Nazis. We obtained a very large second house and partitioned the quarters to shelter the Jews as well as the partisans. For eighteen months we all lived as brothers and participated in all the celebrations, both Muslim and Jewish.

When the Nazis began house-to-house searches, we took the Jews to various remote villages. They thought of us as saints.

After the war we lost all contact. In 1982, our cousin heard a Jewish woman on the BBC inquiring about her rescuers in Berat. That is all we know. It is difficult to remember names after sixty years.

Our parents were devout Muslims. We are now more secular Muslims. We are proud partisans and have been honored by our country for the sacrifices we made in sheltering Jews and partisans during the occupation. We live with the tradition of Besa. There is a saying: We would sooner have our son killed than break our Besa.

Orhan Frasheri
Xhafer Frasheri

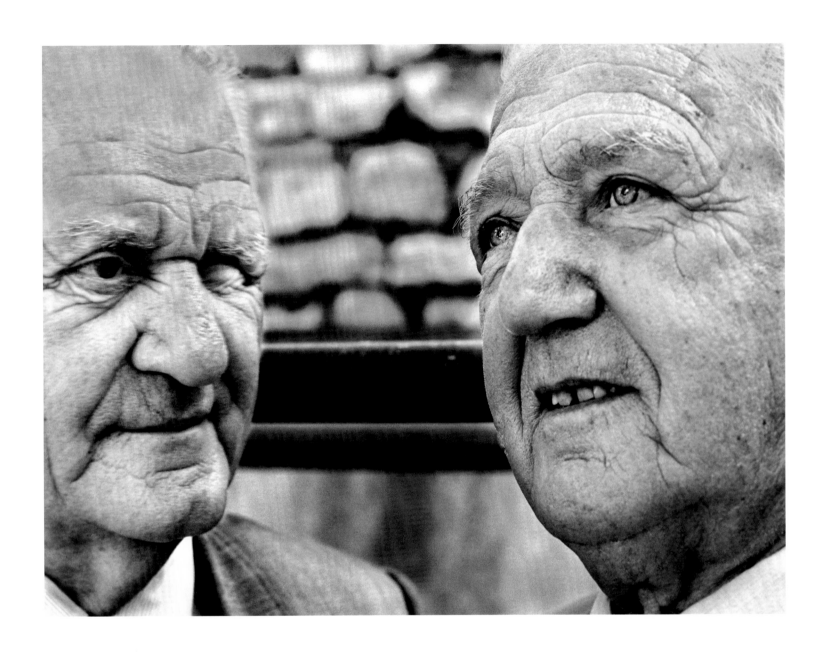

*Orhan and Xhafer Frasheri.*

# Family of Toli Dodi

I REMEMBER Josef Abraham Adyzyss very well. How could I forget him? He came to work for my father, a carpenter and contractor in Berat, in 1942. We called him Yusa. Our home is still filled with the furniture he made while in hiding during the Nazi period. He made this table.

In late 1943, when the Italians capitulated to the Allies and the Nazis moved in, there was chaos and fear. That is when Yusa was sheltered in our home. Many Italian soldiers were also hidden from the Nazis in our community. The Nazis knew that Jews were in hiding along with Italian soldiers, and as retribution they began burning down our entire district. Italian soldiers came out of hiding to help put out the fires. We were forced to leave our home, and we lost a lot of our possessions. But Berat was a fiercely patriotic city, and many partisans from our community, including my two older brothers, went into the mountains to fight the Nazis. It was at this time that Yusa joined the partisans in the mountains. In 1945, there was a joyous celebration in the city of Shkoder when my two partisan brothers were reunited with Yusa.

Forty-four years later, in 1989, we again made contact with Yusa. He was living in Jerusalem and had a fine family. We have his address. It brings tears to my eyes to say that I hope to be reunited with Yusa before I die.

The deed of our family is done. We seek no publicity for what we did. God made Jerusalem the capital of the world. We pray for the continued enlightenment of Jerusalem.

Josef Dodi

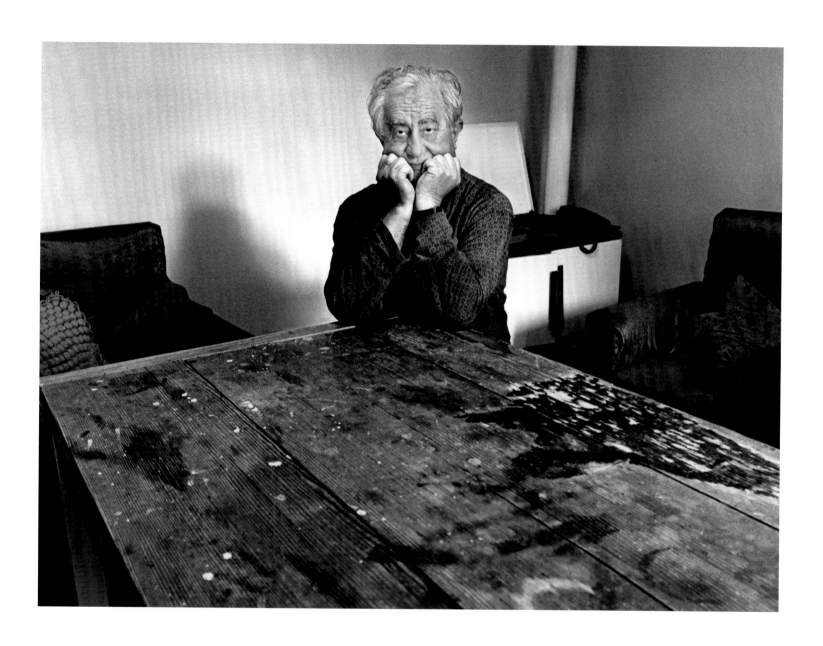

*Josef Dodi, behind table made by Josef Adyzyss.*

# Family of Ali Ohri

I AM CHAMBERLAIN and head of the Office of the Royal Court of Albania. My family and I have always been royalists, loyal to King Zog and now to his son, King Leka I, who recently returned to Albania from his long exile.

In 1941, many of my cousins were involved in sheltering Dr. David Baruch, his sister, and five cousins. We gave him the Muslim name of Daut Baruch. Though he was originally from Czechoslovakia, Dr. Baruch was the chairman of the largest hospital in Skopje, Macedonia. I was young at the time and I went to school with several of Dr. Baruch's younger cousins. Under the Nazi occupation, when Tirana became too dangerous for the Baruch family, we moved them to the small village of Kruje, where members of my extended family sheltered them.

Dr. Baruch was originally a member of a royalist resistance that fled from Skopje, Macedonia, to Pristina, Kosovo, to avoid the Nazis in 1941. Then they came to Albania and continued the resistance, now against the communists and the Italian fascists. When the Italians capitulated to the Allies in 1943, Dr. Baruch was still active as a royalist; he fought the communist partisans until 1944. It was easy for my family to give shelter to a fellow royalist. It was human-to-human relations, and true to our Muslim faith.

Since the end of 1944, when Dr. Baruch and his family returned to Skopje, we have lost all contact.

Ali Ohri

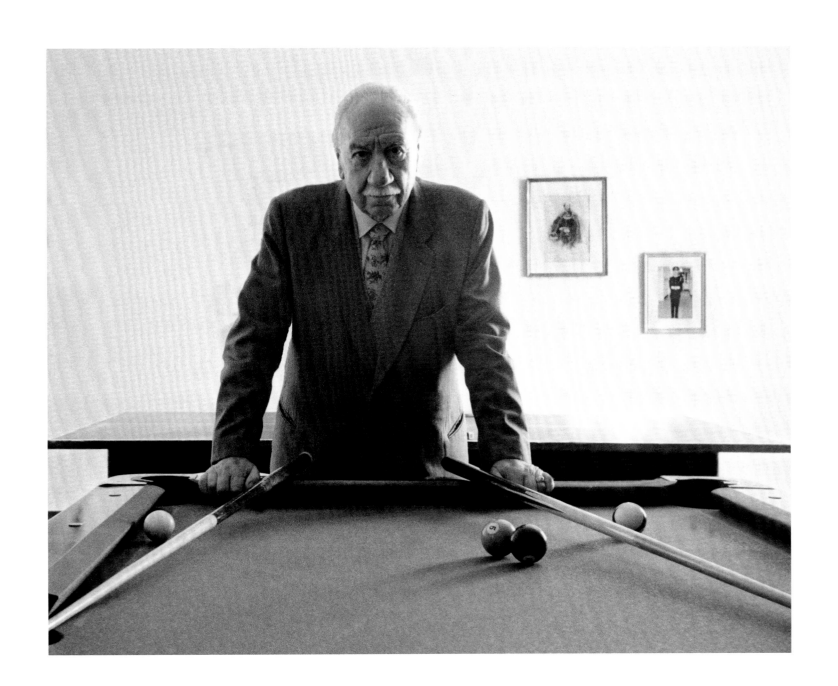

*Ali Obri.*

# Family of Sulo Muzhaka

WE ARE a large family of ten children, all born after the war. In this picture I am with two of my brothers and my nieces. When I was very young my father told us about nine Jewish families from Pristina, Kosovo, that he had helped shelter during the war. I do not remember their names.

My father had a bicycle repair shop in our town of Berat. He was the chairman of the National Liberation Council, our neighborhood resistance organization against the Italian and Nazi occupations. He told us that immediately after the Nazis entered Berat he helped secure the Jews against any danger by taking some into the small village of Shpirag and hiding others in Berat with fellow partisans.

Another partisan, Gjylfizare Qolja, told us that when they took the Jews out of town to hide them in the countryside, the Jewish children began crying because they did not want to leave Berat. They asked, "Isn't there any other Berat where we can go?" One of the resistance fighters reassured them by saying, "Berat is everywhere, because wherever you go in Albania, the Albanians are there to protect you."

Isa Muzhaka

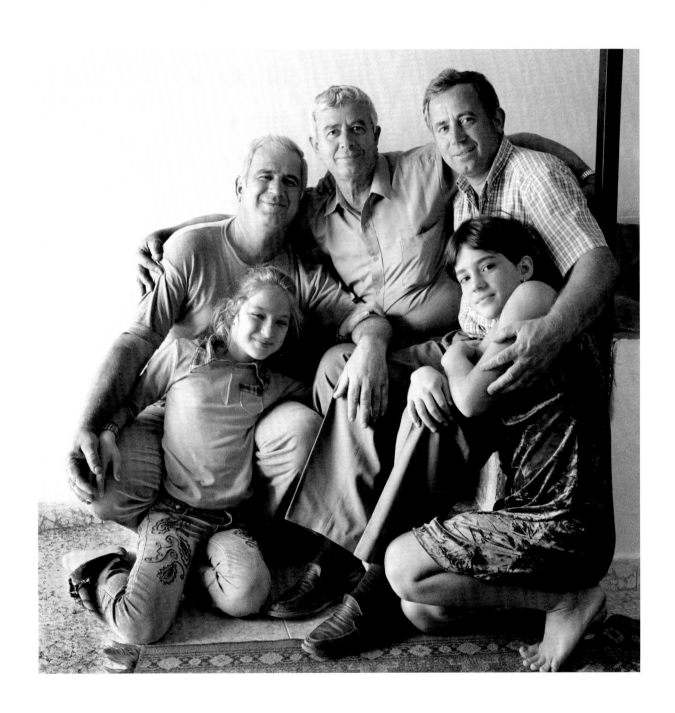

*Sons and granddaughters of Sulo Muzhaka.*

# Family of Ali and Nadire Binxhiu

OUR ENTIRE FAMILY was involved in fighting the fascists. My parents were part of the National Front, the royalist group under King Zog. My uncle headed the resistance.

First we sheltered a Jewish family, friends of my uncle, in our home in Tirana. Then our house became a safe house and a major staging area for Jews seeking help. We moved many Jewish families to the village of Zall-Herr, where the National Front was bivouacked. There were twenty families protected in Zall-Herr. Among the Jews and the partisans in the village were a German officer who had deserted and a Russian soldier.

This work by my parents was extremely dangerous, and they had to be very careful. My parents were brave and were never frightened. No one in our neighborhood knew of their activities.

In 1945, we lost contact with all those we had worked with and saved. Under the communists, no letters from abroad were permitted. Our family was persecuted. We lost our property and many jobs because we were royalists.

We never sought a reward.

This is a picture of my mother holding one of her grandchildren.

Hysref Binxhiu

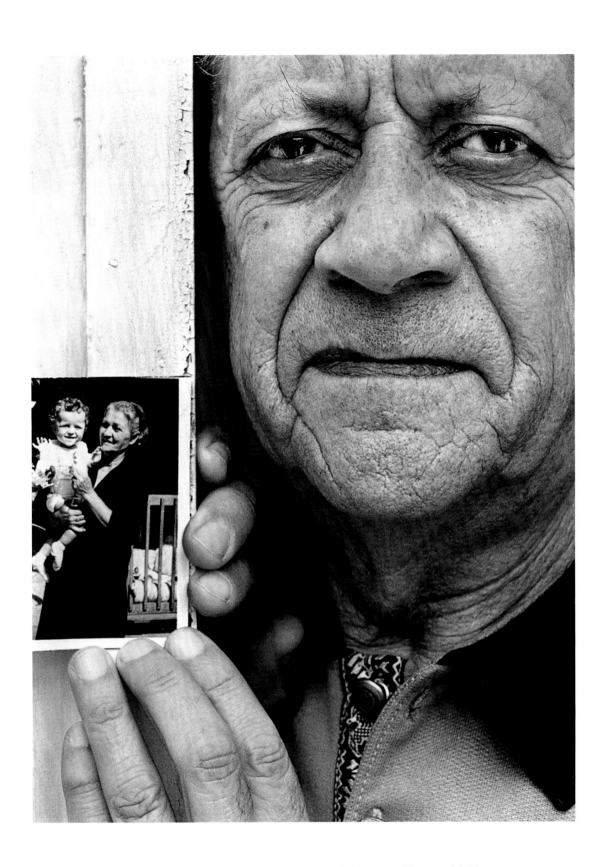

*Hysref Binxhiu, with photograph of his mother holding one of her grandchildren.*

# Family of Qani Civeja

WE ARE A TRADITIONAL Muslim family of scholars who have been in Berat for six generations. Our city is very old, with continuous settlement for more than twenty-four hundred years. I have been a teacher and imam for thirty years. Our whole family both studies and practices our religion. The chemistry of life and good will lives in the Holy Koran.

I will read from our family diary of those times when we sheltered ten Jewish families in our home:

> The Jews arrived by truck fleeing the Nazis from Pristina, Kosovo. There were many families who arrived as refugees in three waves from Pristina. All were sheltered by many families in Berat. Many of the fleeing Italian soldiers were also sheltered. We gave to the extended Jewish families our large house. We moved into a smaller home. The Jews initially were uncertain, frightened and confused. Our home was their home for more than one year. Toward the end of the war, times became extremely dangerous in Berat. The Nazis bombed our city and the Germans were hunting Jews and partisans with a scorched earth cruelty. Along with our Jewish guests, we moved into the nearby mountain village of Kamcisht, where our uncle lived. We dressed the Jews in ill-fitting peasant costumes. We told them: "Wherever we go you will go."

Our mother cooked for all the families. Our mother had "sweet hands." The Jewish families practiced their prayers at holidays and always said prayers in silence before meals. There are so many names of those we sheltered. Mostly we recorded first names. There was Josef and his wife Rogjina, with twin boys and a daughter, Sonja. Sonja was my playmate. There was Isak, the brother-in-law of Josef, his wife, Bembe, and his son, Sami. There was Jacov Conforti and his sons, David and Kuti. Those are the only names written in this diary, and all I can remember.

I recall when the Jewish families left. They gave us many gifts of decorative scarves, plates, and embroidered pillowcases. There were many tears. They promised to write, but we never heard from them again. We think the Germans caught many of them.

These memories come alive as I read from our family history. Our generation has a special feeling for the Jewish people. Our father wrote that when he had the opportunity and privilege to shelter so many Jewish families it gave him joy to put into practice his Islamic faith. To be generous is a virtue.

Kujtim Civeja

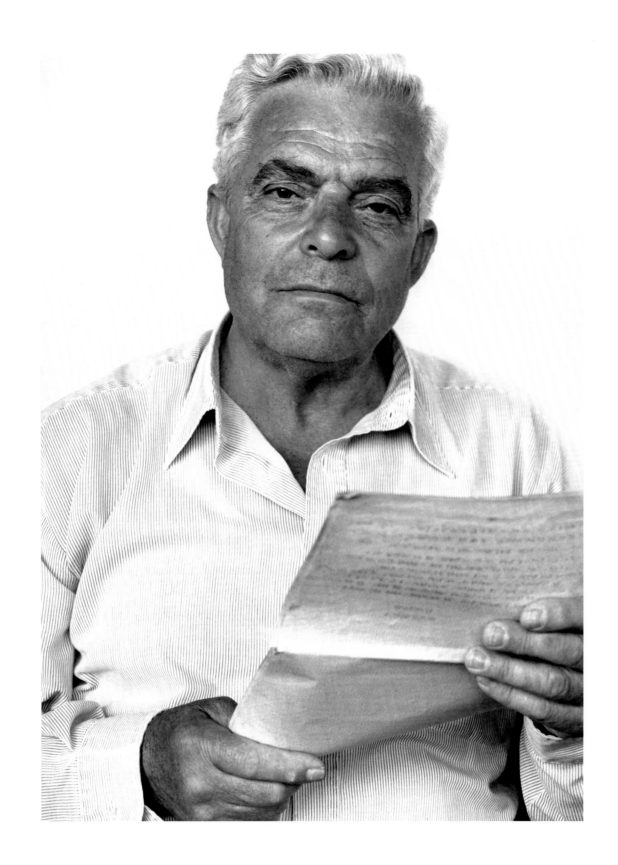

*Kujtim Civeja.*

# Family of Destan Kormaku

WE LIVED in the town of Elbasan. I was twelve years old, and my two brothers were younger. It was just a few steps from here that our father sheltered six Jews in a stone house much like the one we lived in. They were Raphael Cambi, Chaim Isaac, and Leon Isaac with his wife and two children. The Isaac family spoke Serbo-Croatian, as did our father. In 1945, they left for Yugoslavia.

Leon Isaac came back for a visit in 1948. He and his family were living in Macedonia. To show his gratitude for saving the lives of his family, he wanted to give my parents a restaurant in Macedonia, and offered to pay all their expenses for ten years. Our mother did not want to live in Macedonia, so we stayed in Elbasan. After 1949, we lost contact with the Isaacs. The communists then imprisoned our father.

We have never sought recognition, but we are glad for this opportunity to have our father remembered. It is in the Koran that in the name of God we help all humans.

This portrait of my father was painted by my daughter, who now lives in Italy.

Isak Kormaku

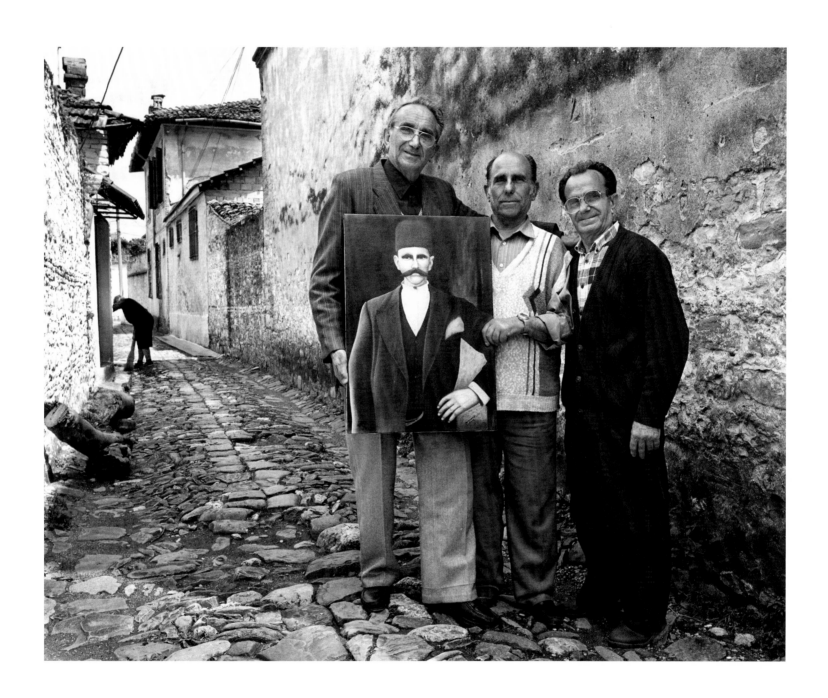

*The sons of Destan Kormaku with a portrait of their father.*

# Family of Besim and Higmete Zyma

IT WAS 1944. A friend asked us to shelter an aged Jewish man from Poland. His name was Lev Djienciolski. Why not? My husband Besim was a wonderful physician. He worked at the hospital, and we had a clinic in our basement. I recall that Mr. Djienciolski could see from only one eye. What my husband did was to bandage his entire face, then hide him in our clinic. The Nazis did not bother us.

I still live in the same apartment that my husband and I did then. I am an artist. These are two of my paintings. The portrait is of Besim, now deceased.

Why hide a Jew? We just did it. It was the thing to do. After all, our Jewish guest was a friend of our friend. Yes, we are Muslims, but secular Muslims.

Higmete Zyma

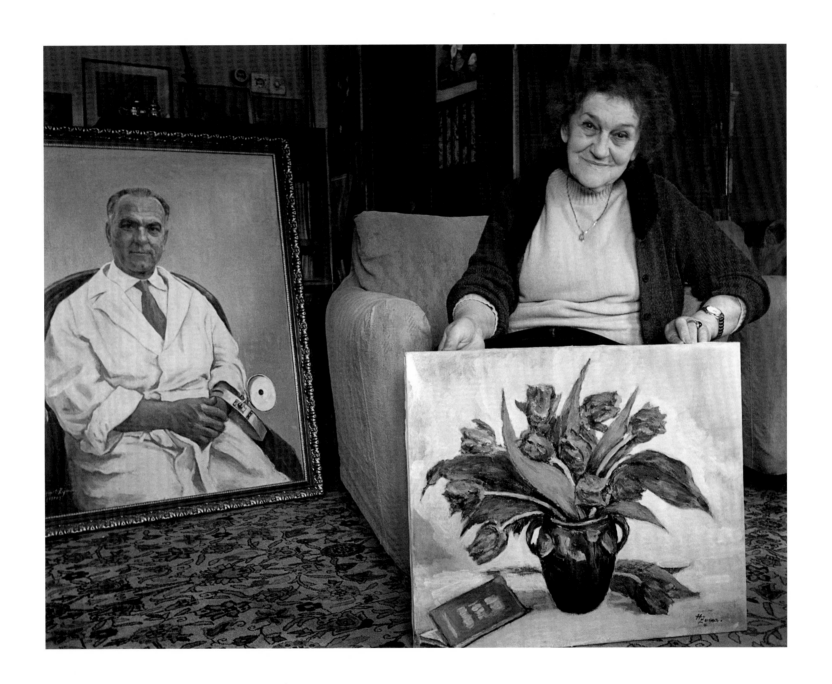

*Higmete Zyma, displaying her paintings, including a portrait of her late husband, Besim.*

# Family of Hajdar Kika and His Son Petrit

OUR HOME was in Kruje. We were a small village, and everyone knew everyone else. We were a family of traders and owned a produce store. I sat on the shoulders of my father. I am the oldest of three brothers and was fifteen in 1943, when the Germans arrived in small numbers. I remember Jews arriving from the village of Mati in Germany, as well as from Belgrade, Prague, and Poland. All were sheltered in our village.

All of Kruje knew of the sheltering of Jews. Even before the arrival of the Germans, our village had sheltered Greeks who were being deported by the Italians. We were all resistance fighters against Rome, Berlin, and Tokyo. At night we listened to the BBC to follow the progress of the war on our battery-operated shortwave radio.

I remember Leon Blumenfeld, a trader in vegetables, and Simon from Warsaw, a trader in wine. Both were sheltered in a place near our store, and our shop was their base. Leon sold goods out of his luggage. Simon did not have to work because he had gold. There was also the Battino family—Chaim, Leon, Jakov, Matilda, and little Sandra. Sandra was like my sister. My father was especially friendly with Chaim Battino. Even under the communists we kept up contact with the Battinos. My children knew their children. Later the Battinos moved to Israel, and we have letters from Jakov and Chaim.

I am now twenty-three years retired. I am blessed with five children, ten grandchildren, and even great-grandchildren.

We are secular Muslims. We were never afraid. It was both a great pleasure and an honor to shelter the Jews. We were old friends. It is our tradition.

Petrit Kika

*Petrit Kika.*

# Family of Tef Pogu

WE ARE FROM SHKODER. We were well known and quite wealthy. My husband owned a printing company, a food oil company, and a soap manufacturing company. We owned two large homes with servants. Everyone in Shkoder knew of my husband and his generosity. I am now ninety-two and a bit hard of hearing, but I remember those times very well.

My husband hid many Jews in and around Shkoder, and he organized other hiding places. He secretly drove Jewish families to our country home, high in the mountains. He also arranged for Jewish families to travel across the sea by ferry to safety in an Allied-occupied territory of Italy. Many of my husband's activities in saving Jews were well known to our employees, and many of them helped in these rescues. My husband helped so many . . . I do not remember their names.

After the war we lost everything to the communists, even our food stamps, but we made do with our hoarded gold. My husband was arrested and spent three years at hard labor. He died in 1957. Our former house still stands, empty and abandoned, in Shkoder.

Xhuliana Pogu

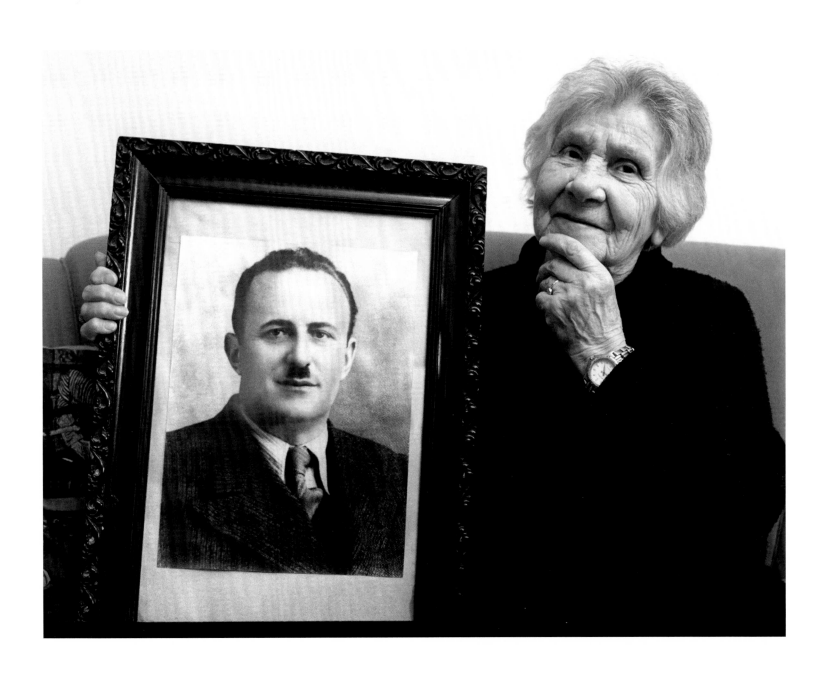

*Xhuliana Pogu, displaying photograph of her late husband, Tef.*

# Family of Yshref and Emine Frasheri and Their Son Mehmet

MY FATHER was a scholar. He owned a printing press and was well known in our country. My great-grandfather was a member of the government before King Zog. Our family is well respected, with a long tradition of learning.

All through the Nazi years we were never afraid to save lives. In 1943, we sheltered Sebita Meshon Gershon, his wife Berah, and their daughters, Hana and Stela. They left for Yugoslavia at the end of 1944. We sheltered Jakov (Jasha) Altarac in our second home in Kamez. He came from Poland and had escaped an Italian camp in Burrel in 1943. We also sheltered Joseph Lazar Gertler from Germany, who had likewise been interned by the Italians in Burrel. Our neighbors never knew.

My father received a warm letter from Joseph Gertler from London in 1956. In 1990 I made contact with Hana and Stela Gershon, who were both living in Brazil, and with Jasha Altarac, who was in Israel.

After the war, the communists arrested and imprisoned my father. He was guilty of being an intellectual.

I still live in Tirana. I owe my good health to my life as a gymnast.

We lived with the Koran's teaching to take care of the other.

Mehmet Yshref Frasheri

*Mehmet Yshref Frasheri.*

# Family of Osman and Nazlie Alla

MY HUSBAND was a military officer all his life. He was retired when he died, just a month ago. It makes me proud to talk about him, but in my heart I am very sad. During the Italian and German occupations, he was a partisan. He was arrested by the Italian fascists, but he escaped.

In the years 1943 and 1944, we sheltered three Jewish families. We had a big house, but we also rented another house where we hid one of the Jewish families. The Jews never went out because it was too dangerous. One family was from Janina in Greece, another family was from Slovakia, and the third was from Germany. We still correspond. We also sheltered many partisans.

As Muslims we welcomed them all. We welcomed them with bread, salt, and our hearts.

Nazlie Alla

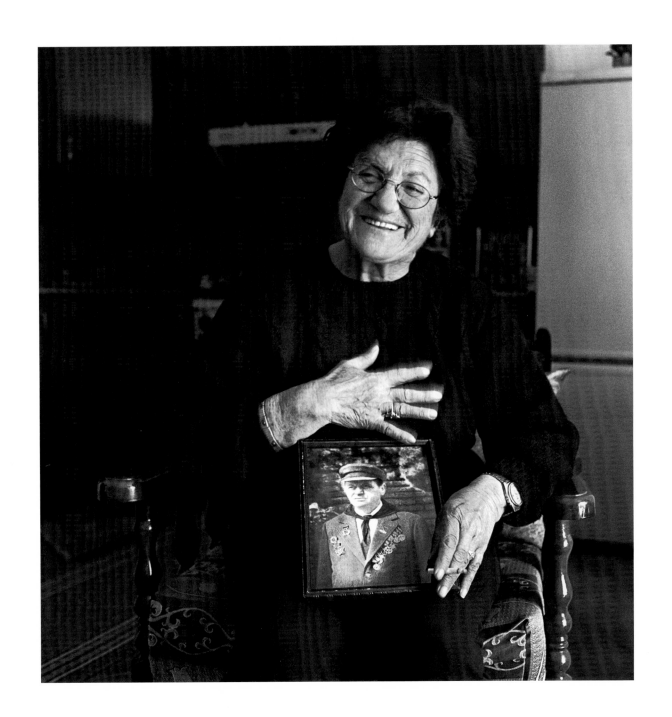

*Nazlie Alla, displaying photograph of her late husband, Osman.*

# Family of Eshref and Emine Shpuza

MY PARENTS LIVED in the town of Durres. In 1944, my father befriended the Jewish family of Raphael (Rudi) Abravanel. They were originally from Yugoslavia. He provided the family with false passports for Rudi, his wife, and two children, and escorted them to the border. They escaped first back to Yugoslavia, then to Italy. Then our family lost all trace of the Abravanels.

It was through the help of another Righteous Albanian, Refik Veseli, that in 1990 we again made contact with Rudi and his family, now living in Israel. We received letters and exchanged telephone calls.

It seems strange to be asked why my father did what he did for this Jewish family. Besa is a tradition of the entire nation of Albania.

Ismet Shpuza

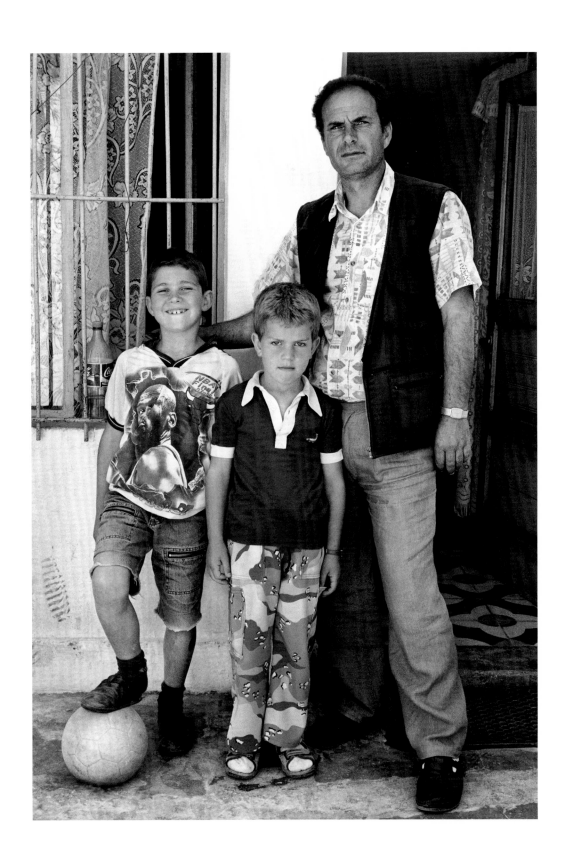

*Ismet Shpuza with his two sons.*

# Family of Ali and Ragip Kraja

SOLOMON ADIXHES, his wife, and his son Isak escaped certain death in Skopje, Macedonia, by bribing a guard and crossing at night over to Albania after the entire Jewish community in Skopje had been rounded up for transport to a death camp. A courier brought them to our fathers, who were twins, shoemakers.

The times were difficult and dangerous for any family to harbor Jews, but we sheltered the Jewish family in our village near Shkoder from 1943 until the end of the war. All three families lived under one roof. We often dressed Solomon in peasant women's clothing to hide his identity. Sometimes he worked in a garment factory owned by a friend of our fathers. Once Solomon cured a peasant of an infection, and the villagers then revered him as a healer. Isak was always peering out the window in fear of a Nazi patrol.

After the war the Adixhes family settled in Israel. In 1994, Solomon and Isak came from Israel to visit our families. What a joyous occasion! A film was made of that trip: *One Wants to Remember— One Wants to Forget.* Last year Isak again visited us, from Los Angeles. We have many pictures from his trip.

We are gathered near the sign that we erected: "The Jewish Refugees of Solomon Adixhes and family drank from this nearby well while being sheltered by Ali and Ragip Kraja when being chased by the Nazis." We sheltered the Adixhes family out of the goodness of our hearts. We are all brothers and proud of our heritage. If need be we would do it again.

Xhevdet, son of Ali

Xhabiri, Myzaferi, and Selami, sons of Ragip

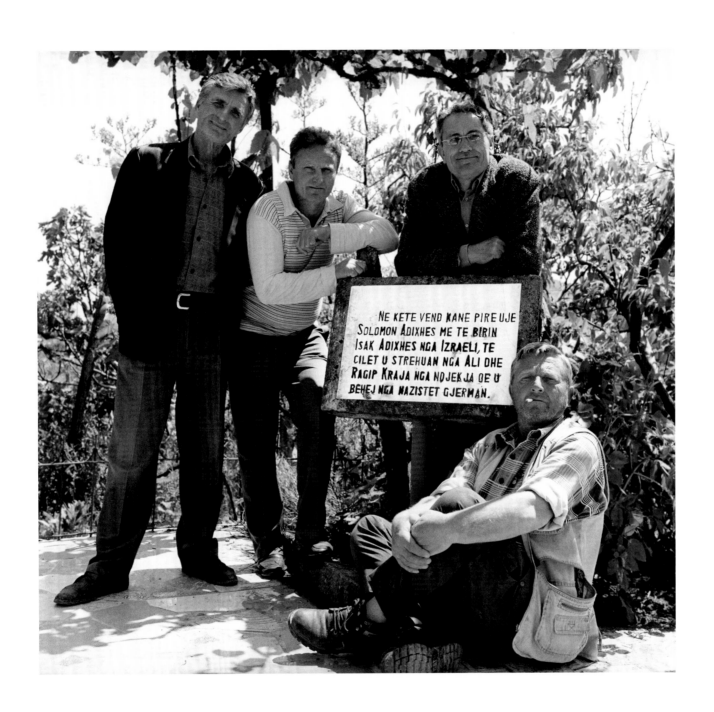

*Sons of Ali and Ragip Kraja.*

# Family of Ismail Gjata

MY FATHER was a grain trader and also owned a children's clothing store in Fier. The Jewish family of Nesim Bahar were refugees from Macedonia in 1942. There were Nesim, several children, his wife, and her sister. Nesim worked in my father's clothing store.

In 1943, the Germans occupied our village. That is when we dressed the Bahar family in peasant clothing and moved some of them to the nearby village of Levan.

My father and his entire family were very kind people. It is hard to believe, but my father gave the clothing business to Nesim, accepting no compensation. Nesim was a good employee and we were happy that he now was the owner.

In late 1944, Nesim and his family left our village to return to Macedonia. We received many letters from him until he died. In this letter, Nesim wrote, "If I had wings to fly, I would come to kiss the sainted Albanian land, which saved our lives." Later Refik Veseli, another Righteous Albanian, made contact with Nesim's widow.

Verushe Babani

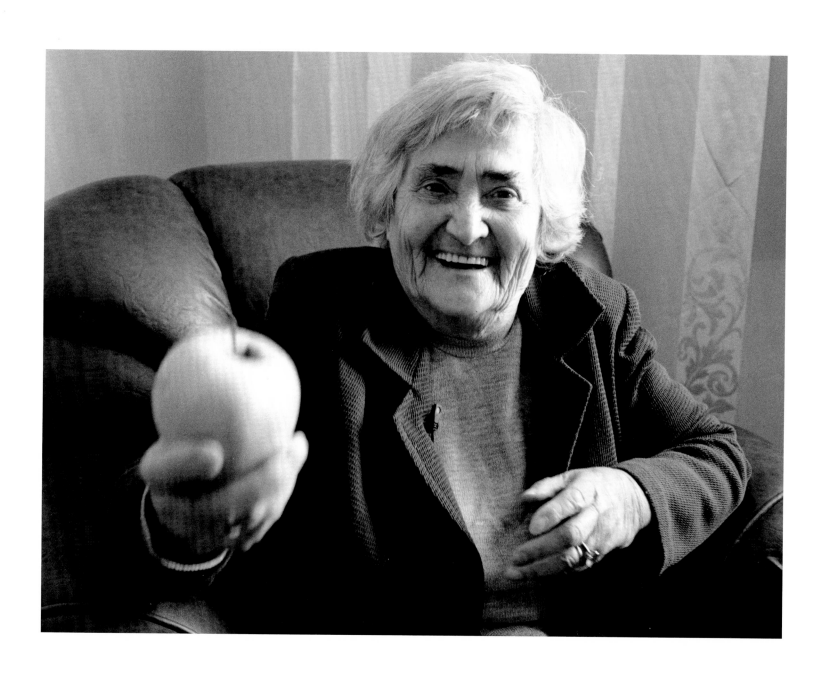

*Verushe Babani.*

# Kasapi Family

HAMDI KASAPI, my husband, died in 1989. He was a cinematographer who was proclaimed an Albanian Hero of Labor. He and his mother, Zyrha, have been honored by the state of Israel as Righteous Among the Nations.

I and my sons, Naim and Francis, treasure what Hamdi and Zyrha did for the Jewish Moisi family: Francis Moisi, his wife, two children, and mother. They came from Skopje in Macedonia, and were sheltered in our home in Tirana. Hamdi spoke the Macedonian language. We sheltered them for more than two years between our small apartment in Tirana and the home of friends in the nearby village of Babrru. This was very difficult, as we had only two rooms.

In 1944, the German terror was very strong, with house-to-house searches in Tirana. By then we had given the family Albanian names and clothing and moved them to Babrru for greater safety. One day Mrs. Moisi and her children had walked to our home from Babrru for a visit, but then they were obliged to stay the night because of German patrols. That night the Germans pounded on our door. Mrs. Moisi escaped through the back door that connected to another house, and the children hid in the bed with the children of our family. The Germans beat Hamdi until he was unconscious. Then they left. The Moisi children witnessed the Germans' brutality against their protector.

The family survived the war and returned to Macedonia. In 1948, they immigrated to Israel. We lost all contact until 1990, when Refik Veseli, the first Albanian recognized as a Righteous Person, made contact with the Moisi children, Marcel and Eni, in Israel. But that was after Hamdi's death.

Both Hamdi and Zyrha were devout Muslims. They believed that it is a moral duty to help one another. Religion was part of our family education. It would have been inexplicable to denounce Jews in need. Fifty years of communism has diluted our devotion.

Adile Kasapi

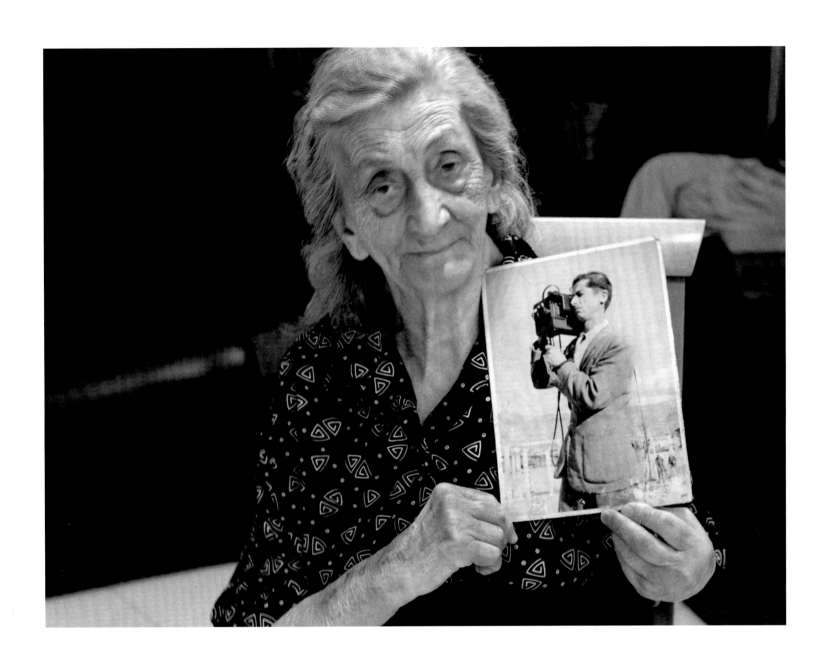

*Adile Kasapi, holding photograph of her late husband, Hamdi.*

# Family of Sulejman and Zenepe Mece

I A M the grandson of Sulejman and Zenepe Mece. Nadire is the wife of my Uncle Ismail, who is now eighty-three and is not well.

This is the same house in which we sheltered twelve Jews, some for as long as two years. Our house is located outside the village of Kruje. Our family had landholdings and owned a shop. We had olive groves and flocks of sheep. Because the path down the mountain to the house is treacherous, we were safer than some during the war. The Germans did not like to come down the path, and we were rarely subjected to searches.

We took in the extended family of the Battinos—brothers, their wives, and their children. My grandparents did not know them, but they were all friends of close friends of ours. We hid them in the attic and they never left the house.

One day a villager we believed to be an informer asked my grandfather Sulejman if he could visit those he was hiding. My grandfather told him if he dared to approach his house or to inform the Germans, my grandfather or other villagers would kill him. For many days Uncle Ismail stationed himself in front of the house with a gun. The danger eventually passed.

In December 1944, the Battinos returned to Tirana. Until the communists made it too difficult, there was close contact between our two families. We know that Jakov and his sister Sandra finally immigrated to Israel in 1994. Uncle Ismail sent them off. Since then we have continued the correspondence.

Presently I serve my community in Kruje as a member of the town council. All my family's land was taken away by the communists. We were left with only this house.

We never took money from those we sheltered. We took them in under our Besa. We are true Muslims, and God granted us the privilege of saving Jews. All life is precious and given by God. To save a life is God's gift. My grandparents and my uncle were unafraid. They had full consciousness of what they were doing.

Hamdi Mece

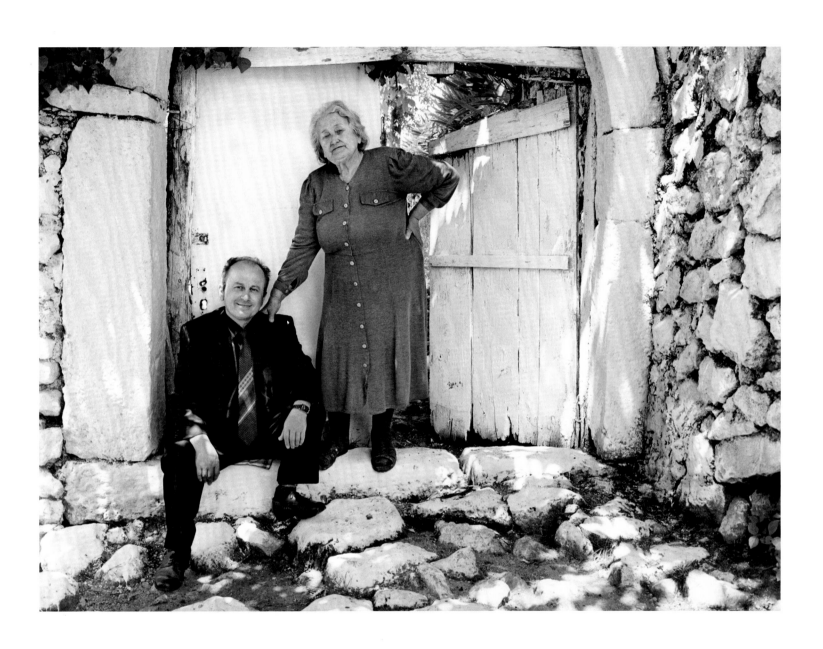

*Hamdi Mece and his aunt, Nadire.*

# Families of Lilo Xhimitiku and Taqi Simsia

OUR HOMES were adjacent and our families were very friendly. One family was quite well off and one was quite modest. One father was a well-known photographer in Berat and one was a shoemaker. Even though one family was rich and one was poor, we got along quite well.

In 1942, three Jews from Pristina, Kosovo, were brought to us by a courier. There was Raphael, a tailor who wore a beautiful suit; Isak, a carpenter who was an old man; and Leon, a house painter. They ate their meals in the smaller home and slept in the larger one. This was a good arrangement because no one would guess that there were guests in a poor man's home. We sheltered the three for more than a year. They dressed as Albanians and worked at their trades in the town. Before they left every morning, we would check the neighborhood to avoid German patrols.

The Germans kept moving in and out of our town, because Berat was a partisan city and all of the people were sheltering and providing food for the partisans. Many citizens were also sheltering Jewish refugees from Pristina. We were warned to keep our doors unlocked or we would be killed. We knew when the patrol was coming because we heard the thump of their boots. One day a German patrol entered our homes looking for partisans. Quickly, Raphael hid behind a hole in a wall, Isak jumped into a closet and Leon ducked under the bed. Our families were panicked yet we kept outwardly calm and offered the Germans our homemade raki. We drank with them so as to engage them, and we all got drunk. The German officer warned us that next time, the Gestapo might be coming and there would be fires and blood.

There was a rumor that the partisans were going to attack. The Gestapo ordered all homes in our district to be vacated. We all took shelter in the forests. The partisans did attack and there was panic. When we returned, we found that one house was completely burned. Soon after, both our fathers were arrested and were lined up against a wall with other suspected partisans to be shot by a firing squad. Just at that moment, a partisan patrol from across the river shot and killed the German officer. The patrol broke ranks and fled. Our fathers were saved. I, Sofir, am standing exactly where my father stood against that wall. Our Jewish guests had escaped into the mountains and never came back to Berat. We don't know what happened to them. Through fifty years of communism all contact has been lost.

I, Petraq, continued in the tradition of family photography, while I, Sofir, am a farmer and still poor.

Petraq Xhimitiku
Sofir Simsia

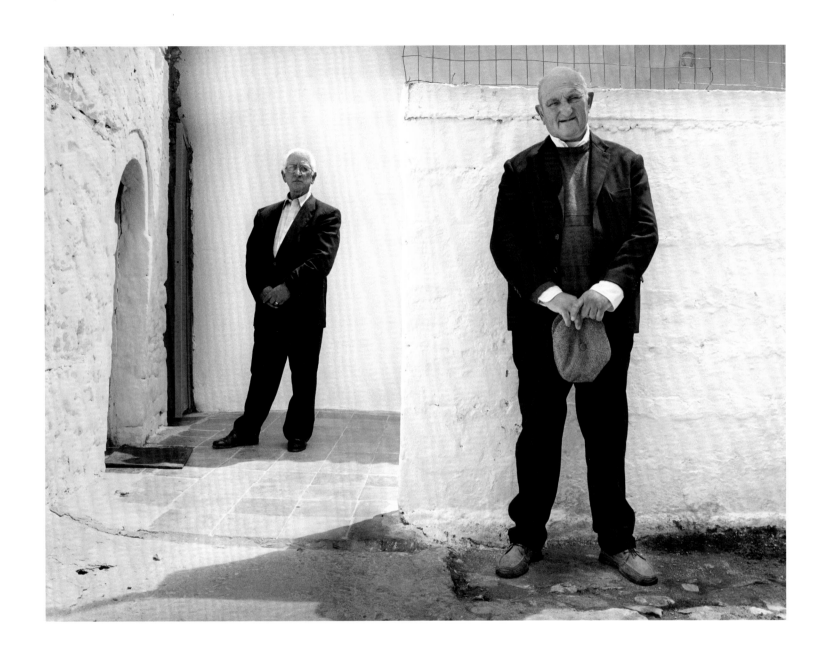

*Petraq Xhimitiku, back, and Sofir Simsia.*

# Kurti Family

OUR FATHER was a milkman. During the German occupation, the proprietor of a store told him about some Jews who needed help. They were Albert Zhubin, his sister Dudie, her husband Edmond, and Mona Iliaz. We hid them all for eighteen months. Then our father arranged false passports, a relative of ours drove them to a seaport, and they escaped to Italy. We think they eventually made it to America. The Zhubin family left behind a radio, a cabinet, and this sewing machine.

Even before the Nazis, our father had bribed the Italians to save a Jewish professor from Slovakia. We also sheltered a Greek ship's captain, who left us a gift of these seashells.

Our house was also a partisan house. Our cows were pastured here on our property in the heart of Tirana, and every day we gave milk to the partisans.

Since the war we have lost all contact with the people we sheltered.

We are religious Muslims. Our family has never sought recognition for saving Jews. To do good is to get good from God.

Sali Kurti
Gugash Kurti

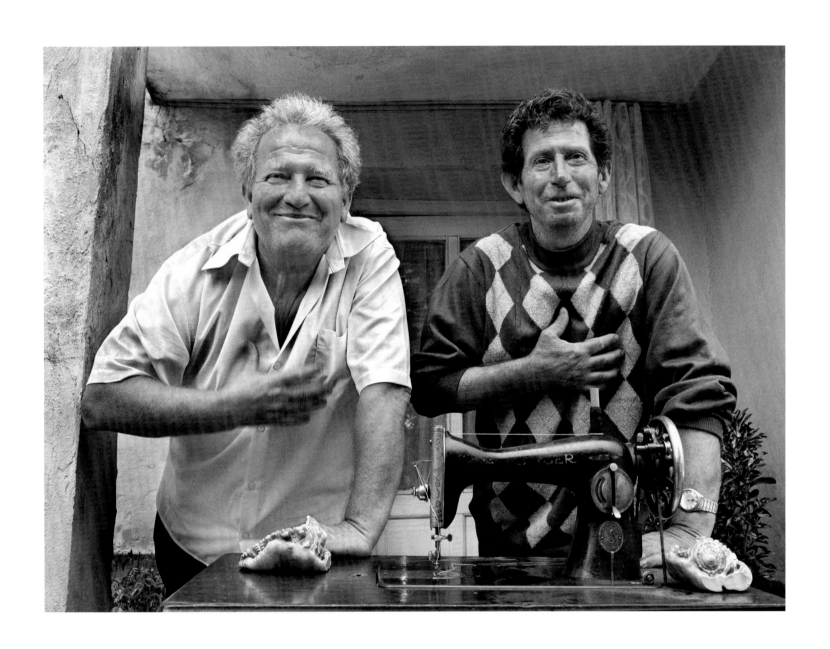

*Sali and Gugash Kurti.*

# Family of Besim and Aishe Kadiu
# and Their Daughter Merushe

WE LIVED in the village of Kavaja. In 1940, our family sheltered two Greek Jews from the Italian fascists. Their names were Jakov and Sandra Battino, and they were brother and sister. They came to us from Tirana. Their father had been interned by the Italians in a camp. Later, in 1943, both Jakov and Sandra again sought shelter with us, fearful of the Nazis. Another family took their parents into hiding.

Sandra, Jakov, and I were close friends. We all lived in the same bedroom. I remember we cut a hole in the bars of our rear bedroom window so they could escape if the Germans discovered that they were hiding with us. We were constantly watching for German patrols. When the Germans began house-to-house searches, looking for Jews, my father took Jakov and Sandra to a remote village. We then supplied all their needs until the liberation in 1945.

When liberation came, there was a great celebration in Kavaja. I remember the telegram we received from Jakov and Sandra and the joy we felt. Soon they left for Tirana and then for Israel.

I have so many wonderful letters and pictures from Israel. In 1992, I was invited there to receive the Righteous Among the Nations award on behalf of my family, and for a time I was the head of the Albanian Israeli Friendship Association.

Those years were fearful, but friendship overcame all fear. My father said that the Germans would have to kill his family before he would let them kill our Jewish guests.

Merushe Kadiu

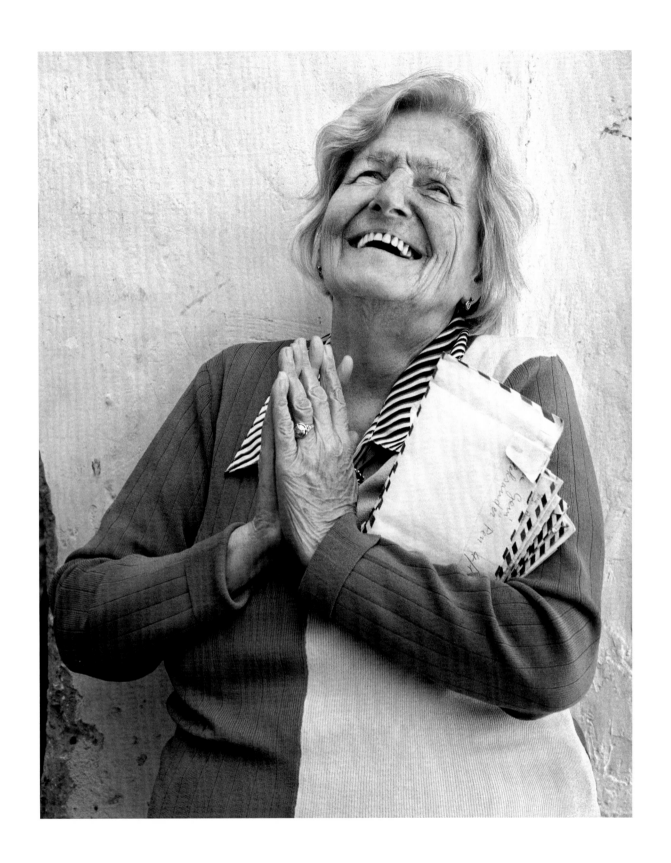

*Merushe Kadiu, with letters from Israel.*

# *Kuqi Family*

MY FATHER owned a hotel restaurant in Mamuras. I was twenty years old, and a partisan. I owned a Ford truck and would drive to Tirana for provisions.

We sheltered five Jews from Belgrade, Yugoslavia. They were the family of Dr. Validgi—mother, father, sister, brother, and a sister-in-law. Another sister we hid in a nunnery. The Validgi family was terrified, but we were never afraid.

At the beginning of 1945, they all left for Belgrade. Almost sixty years have passed since we said goodbye, and since then we have had no contact. I do not know their real names and have always hoped that some members of their family would contact us.

I have pictures of me with this Jewish family walking in a square in Tirana. Yes, walking in Tirana with our Jewish friends! I had no fear and showed no fear.

I am proud of my life as a partisan, a communist, and a Muslim.

Our motivation was Besa.

Shaban Kuqi

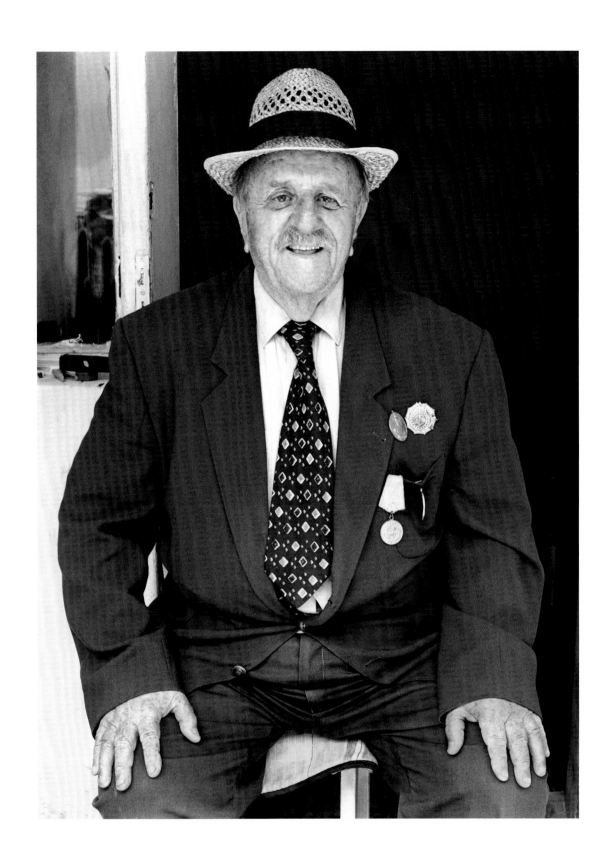

*Shaban Kuqi.*

# Family of Nuro Hoxha

I AM the oldest son of Nuro Hoxha, who was well known as a teacher and a religious Muslim here in our community of Vlore. I remember those terrible times when the Nazis moved into Vlore from Greece, and the Jews went into hiding. I was ten years old. The Jews in Vlore, Berat, and Elbasan had been living in Albania since 1490, and many more fled here from Janina in Greece. My father sheltered four Jewish families. They all were his friends. I remember my father's words to those he took in: "Now we are one family. You won't suffer any evil. My sons and I will defend you against peril at the cost of our lives."

We hid the families in underground bunkers that extended from our large house. They included Ilia Sollomoni, his wife and three children, and his sister-in-law and her husband, as well as Moses Negria, his wife Fauto, and his two brothers. There were many others whose names I do not recall. The bunkers were connected, and had many escape routes. It was my job to take food to the families in the bunkers and to shop for necessities.

All the inhabitants of Vlore were antifascist, and all knew that many families were sheltering Jews.

As devout Muslims we extended our protection and humanism to the Jews. Why? Besa, friendship, and the holy Koran.

This is a picture of my father that I hold to my heart.

Sazan Hoxha

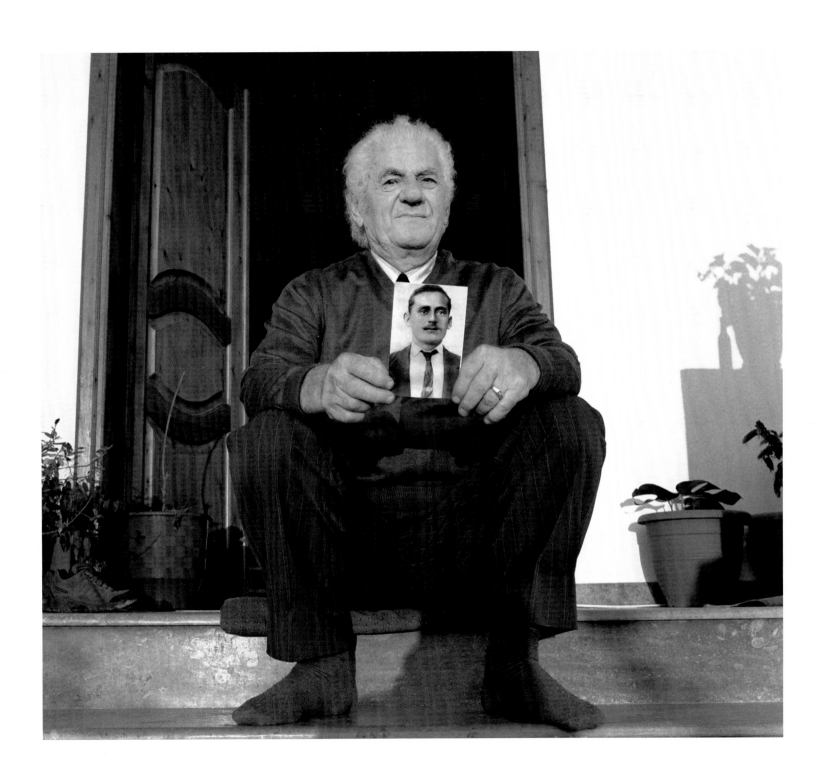

*Sazan Hoxha, with photograph of his father.*

# Family of Muhedin Haxhiu

AT THE TIME of the German occupation in 1944, I was nine years old. My father was a professor of economics. He owned a farm in Vlore. When the Nazis arrived, all the Jewish members of our community went into hiding with great fear, and all the people of Vlore participated in sheltering them.

My father sheltered the families of Pepe Nisim Levy and Josef Rafael Jakoel. He went to the prefect of police and told him, "If our friends the Jews are hurt by even one single hair on their heads, the same will befall all the members of your family." Pepe Nisim Levy was very rich, and it was with his funds that my father went to the mayor of Vlore and obtained false passports for the entire Jewish community. Then we arranged for shelters and eventually for escape routes.

After the war, both Josef Rafael Jakoel and Pepe Nesim Levy wrote testimonials from Israel about my father's work in sheltering the Jews of Vlore.

My daily prayer is a prayer of peace, friendship, and brotherhood. The Koran says to give to a beggar with your right hand and to do it quietly. God will know.

I am the fourth member of my family to go on hajj to Mecca.

With me is one of my grandchildren. Children are the flowers of life.

<div align="right">Avdul Haxhiu</div>

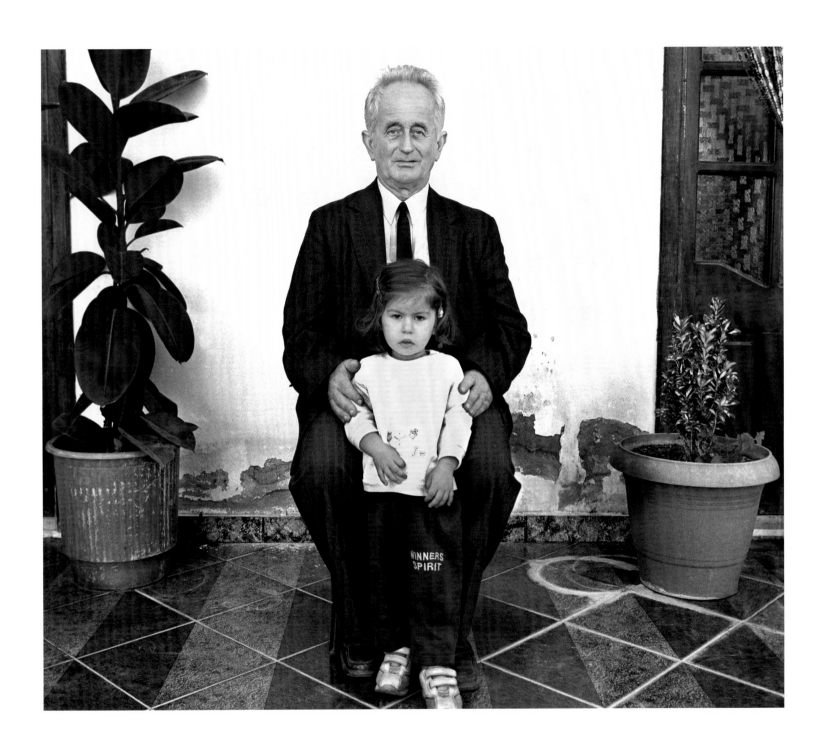

*Avdul Haxhiu and granddaughter.*

# Family of Hasan Kalaja

WE ARE a family of scholars, nationalists, and political activists. My father was a judge before the communists took power. Our grandfather fought in the war of independence in 1912. He is well known in Albanian history. I was a teacher of literature and my brother, Bardhyl, was a physicist.

This is the house where we sheltered a Yugoslav Jewish couple, David and Freda Gabaj, in 1943 and 1944. I was twelve years old. I remember them well. I taught David to speak Albanian and he taught me Serbian. David had been a very rich man in Belgrade, but we took no money from them. They lived in our children's room. They lit candles on the Jewish Sabbath and said prayers. Freda was constantly frightened, and never left her room. I used to take David out shopping. He pretended to be deaf and dumb.

The entire neighborhood—even the local prefect—knew we were sheltering Jews. When the Germans gave an order, on penalty of death, for every household to hang a list of all family members on each front door, we listed David and Freda with false names as our uncle and aunt. We lived day to day as one family. All our doors were always open. In 1945, David and Freda left, and we lost all contact.

In 1946, the communists arrested our father and he spent thirty years as a political prisoner. My mother, brother, and grandmother were deported to Kruje, and a communist general took over our house. We all survived with great difficulty. Our father died in 1985. We finally got our house back in 1991.

Our grandparents were devout Muslims. My brother and I are secular Shiite Muslims. We celebrate the Muslim holidays. My father gave us an order: If there is knock on the door, take responsibility.

Sadik Kalaja

*Sadik and Bardhyl Kalaja.*

# Family of Rifat Hoxha

I WAS BORN after the war. My father only told me of his rescue of a Jewish family shortly before he died, when I was seventeen years old. My father waited until he felt I was mature enough to accept the obligation he had committed to and would be unable to complete.

In 1944, under the German occupation, my parents sheltered the family of Nesim Hallagyem, his wife Sara, and their son Aron. They were refugees from Bulgaria who stayed with my parents for six months. Fortunately, my father spoke Bulgarian, and he and Nesim became good friends. The Hallagyem family had their own room and were treated as special guests. There were times of great danger, when German patrols went from house to house seeking Jews. My father then arranged shelter for Nesim and Sara in outlying villages, safe from German patrols. Aron, who was ten years old, stayed in my parents' home, pretending to be their son.

Toward the end of the occupation, my father escorted Nesim and his family to the port city of Durres, where they embarked as refugees, hopeful of gaining access to Palestine. Just before leaving Nesim entrusted to my father three beautifully bound books in Hebrew to keep until he could retrieve them "when the waters are still," after the war. Nesim was terrified to carry them into the unknown as a Jew. "Save them as you would save your eyes," he told my father.

After the war my father did receive a letter from Nesim that he and his family were safely in Palestine. This was during the communist period in Albania, when any correspondence from abroad was considered a crime subject to arrest. My father was prohibited from answering the letter, and that was the last time there was any communication.

My father gave me both the honor and responsibility of safeguarding these Hebrew books until Nesim or his descendants return to retrieve them. This is a heavy burden and I will be saddened if I have to pass this responsibility on to my son. Perhaps Aron is alive in Israel. Perhaps there are grandchildren. I have never been outside of Albania and do not have the means to travel.

The books remain in my home. They are a treasure. I still await the Hallagyems' return.

Rexhep Rifat Hoxha

*Rexhep Rifat Hoxha, with Hebrew books left behind by a Jewish family his father sheltered.*

# Family of Kasem Jakup Kocerri

I WAS BORN in Vlore in 1915. All my life I have been a sheepherder, living with our livestock in the hills. In Vlore we had many Jewish families who were longtime members of our community. We were the best of friends.

In early 1944, a retreating German division came to our village from Greece. Our entire village was part of the national front of partisans. If the Germans killed one Albanian we felt the right to kill one hundred Germans. The Germans were looking for Jews, whom they said they would burn alive with gasoline as Christ killers.

Jakov Solomon acted as the rabbi of the Jewish community. One night, I took Jakov and his family with horses into the hills and hid them in a barn where I kept the sheep. Another part of the family was hidden with other villagers in the forest. We sheltered parts of the Solomon family for six months, until the Germans left in late 1944. Others in our village took the remaining Jewish families into hiding. The dogs kept all strangers and patrols away. I remember Jakov taking me to a tree where he had hidden ten gold coins. He offered them to me, but I refused.

All the Jewish families of Vlore survived, but the Jews did not know whether their family members were safe until they were all reunited after the Germans left. The Germans massacred many partisans of Vlore, and some were deported to death camps.

The Jewish families stayed in Vlore all through the communist period until 1991. Then some went to Greece, but most immigrated to Israel. We still correspond with Jeannette Solomon, Jakov's daughter, in Israel.

I am proud to be recognized by the state of Israel as Righteous Among the Nations. We have been a family of Muslims for five hundred years. Besa came from the Koran. The Jews and Muslims of Albania are cousins. We both bury our dead in coffins. I salute all the Jews. May they be honored with their homeland because the Jews are still at war and need to be remembered. I drain my glass of raki to honor all my Jewish friends.

To save a life is to go to paradise.

Kasem Jakup Kocerri

*Kasem Jakup Kocerri, with members of his family*

# Family of Xhevat and Aferdita Gjergjani

WE MET this Jewish family wandering in the streets of Berat—Isak Solomon Adixhes, his wife, Sara, and their baby daughter, Sonya. They had escaped the Nazis and arrived from Pristina, Kosovo. We had a large home, and we took them in and sheltered them for six months, maybe longer. Now I am old and unwell, but I remember them clearly, especially Sara. Sara and I were like sisters.

My baby son, Perparim, was just the age of little Sonya. It was God's blessing that they arrived in our home because I did not have enough milk to feed my son and Sara was able to nurse him along with her daughter. We gave Sara the best of attention so that she could continue to feed both babies. It is an Albanian tradition that when the same woman feeds two babies they become brother and sister. So my son Perparim has a sister Sonya, perhaps in Israel.

When the Nazis arrived, the Adixhes family, along with other Jewish refugees, were escorted to several remote villages of Albania. We lost all contact.

Our family are religious Muslims and we honor our code of Besa. I was once asked if I mind that a Jewish mother had fed my baby. I answered, "Jews are God's people like us."

Aferdita Gjergjani

*Aferdita Gjergjani.*

# Family of Vesel and Fatime Veseli

MY HUSBAND was a photographer. He learned his trade as a teenager from a Jewish photographer by the name of Mandil. The Veseli photographic studio is still in business in Tirana, now operated by my son.

The Italians had deported the Mandil family from Pristina to Tirana. When the Germans occupied Albania, my husband got his parents' permission to hide all four members of the Mandil family and four of their cousins in the family's home in the mountain village of Kruje. All eight Jews were hidden until the liberation.

My husband and his parents, Fatime and Vesel Veseli, were the first Albanians to be recognized by the state of Israel as Righteous Among the Nations. When my husband was asked how it was possible that so many Albanians helped to hide Jews and protect them, he said, "There are no foreigners in Albania; there are only guests." Our moral code as Albanians requires that we be hospitable to guests in our home and in our country. When asked about the possibility of Albanians reporting the presence of the Jews to the Germans, my husband said that if an Albanian did this he would disgrace his village and his family. At a minimum his home would be destroyed and his family banished.

Our home is first God's house, second our guest's house, and third our family's house.

The Koran teaches us that all people—Jews, Christians, Muslims—are under one God.

<div align="right">Drita Veseli</div>

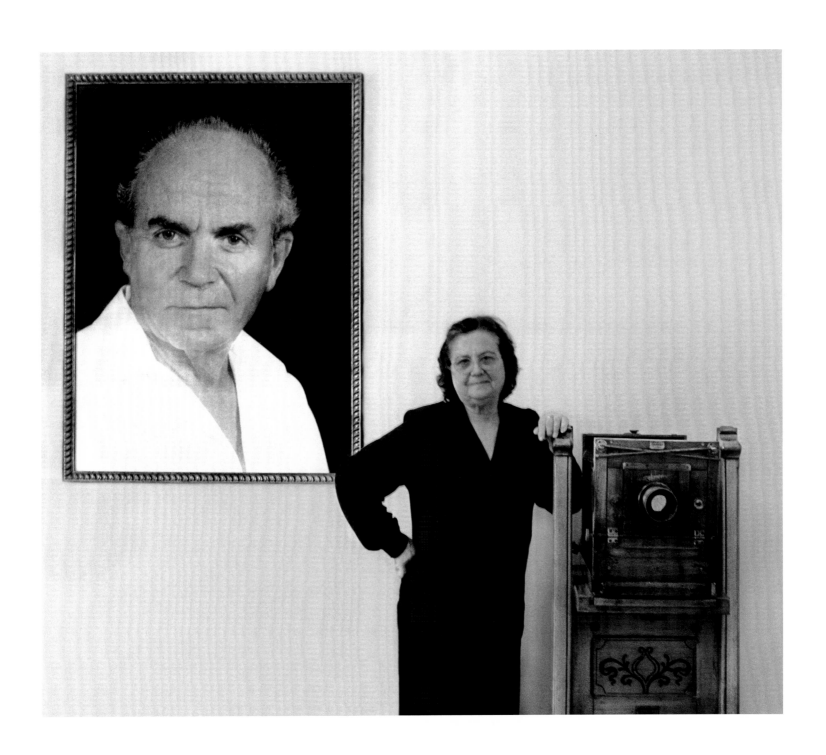

*Drita Veseli, in front of a photographic portrait of her late husband, Refik.*

# Family of Mesut and Drita Salillari

ALTHOUGH Mesut and I were not yet married during the war, I remember the story of the rescue of the family of Shumuel Hajon, his wife, Dorita, and their daughter, Brankica.

We had nicknames for Shumuel and Dorita. We called them Bato and Cuci. The family came as refugees in 1941, from Nazi-occupied Belgrade. We gave them shelter for three years under the Italian occupation. When the Germans moved into Tirana in 1943, we hid their Jewish identity and, with the help of other Albanian families, we moved them from house to house. Since Brankica was only a child, she stayed with us in Tirana.

After the war Shumuel and his family returned to Belgrade, where he became chairman of the railroad commission. In 1948, the communist regime of Albania broke relations with Serbia and we lost all contact with the Hajon family.

It was not until 1991 that my husband and his brother, while traveling on business in Belgrade, searched for the Hajon family and found their empty house. In 1993, with the help of a Finnish official in Budapest, we obtained the address of the Hajon family in Israel. My husband went for ten days to Israel, bringing pictures we had taken during their years in Albania. It was a wonderful reunion. We have so many pictures from that reunion in Israel and they are our family treasure.

I cry with tears of joy for what our family was able to do in saving Shumuel and his family. Besa is in the Koran and that is what we live by.

Drita Salillari
Daughter Freskita

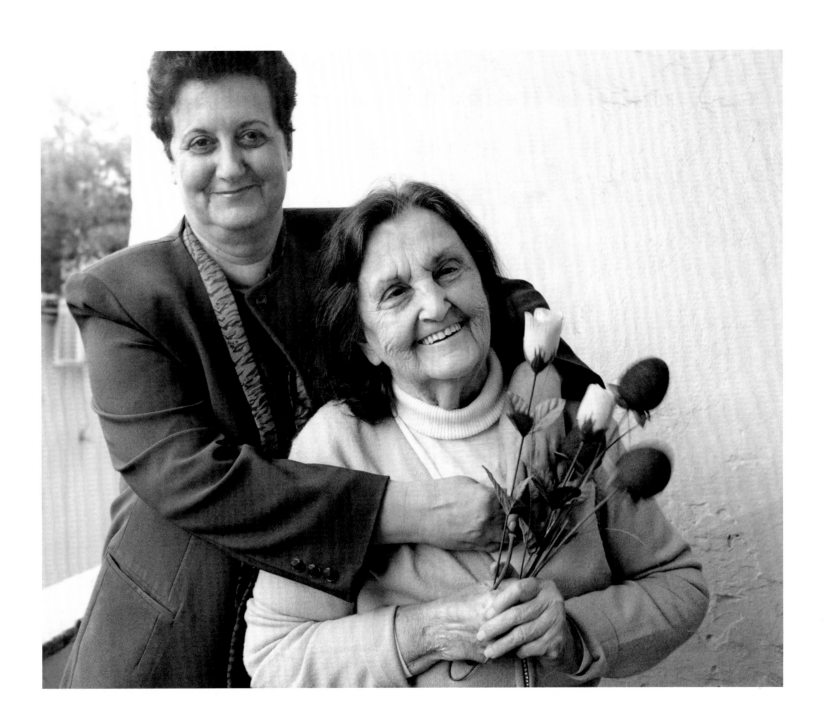

*Drita Salillari, right, with her daughter, Freskita.*

# Family of Xhaferr Skenderi

OUR HOUSE was built in the 1930s in Tirana by my grandfather, who was an imam. This is the same house where we sheltered three Jewish brothers—Chaim, John, and David Battino. The Battinos are an old family in Albania. They were close friends with my father even before the war.

I was seven or eight at the time. My wife and I are standing next to the cellar entrance where the Jews were hidden. There were many searches by the Germans. We put up mattresses behind this entranceway, and also blocked the windows, so that no noise could be heard from the outside. Back then, this neighborhood was forested, and there were backdoor connections between homes. Sometimes the brothers moved to other houses. Often they hid in the woods, and we brought food to them there.

After the war we remained friends. When my mother died in 1979, John Battino paid his respects by bringing us a traditional black shroud.

I know that descendants of the Battino family are in Israel now.

Religion was not the reason my father saved the Jewish brothers. We have a word—*miq*. It means "strong friendship." Friendship was most important.

<div style="text-align: right">Agron Skenderi</div>

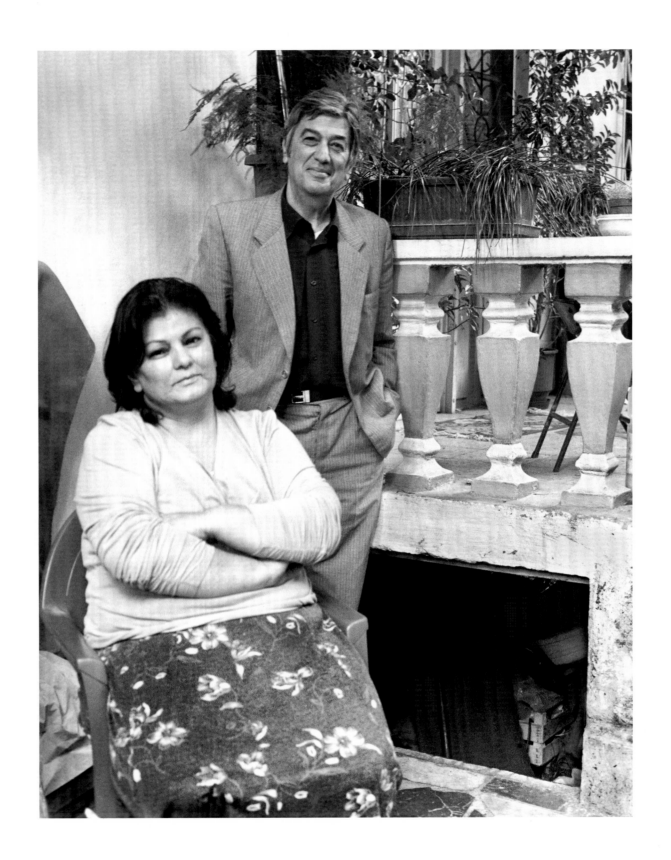

*Agron Skenderi and his wife.*

# Family of Abaz and Zade Sinani

I WAS nine years old. We lived in a big house in the village of Lushnje, in southern Albania. My parents took in a Croatian Jewish family of three—Fritz, Katherine, and their daughter, Gertrude. I do not remember their family name. Our cousin sheltered a fourth member of the family. We gave them false passports, and Gertrude went to school with me. Fritz was a carpenter, and I remember that the family was educated. We always treated Fritz and his family as guests. We never gave them work assignments.

At times the situation became dangerous because of German patrols, so we would move the Jews back and forth between our home and our cousin's home. They stayed with us for six months, and at the end of the war they left for England. After the war we lost contact with all those we sheltered.

We were secular Muslims. In our home we celebrated all the holidays—Jewish, Muslim, and Christian. Why did we shelter the Jewish family? We had the biggest house in the village. Any villager would have done the same.

We also sheltered two Italian soldiers during the German occupation. And in 1912, after the war with Turkey, my mother's family sheltered Turkish soldiers.

Why should we be honored? We did nothing special. We did what any Albanian would do. We are all human.

This is a picture of my father. All else has been lost.

Agim Sinani

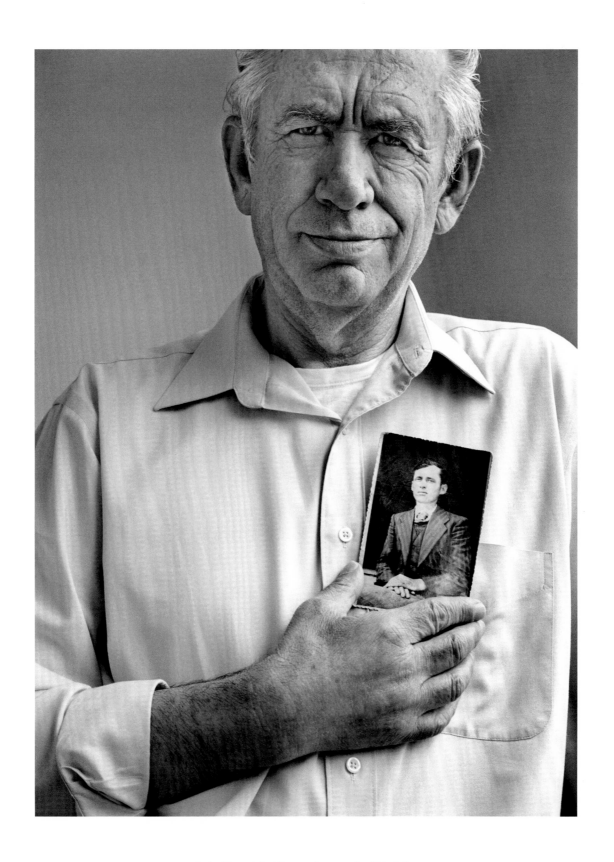

*Agim Sinani, holding a photograph of his father.*

# Family of Ali and Nadia Kazazi

IN 1913, our grandfather sheltered refugees from the war in Yugoslavia.

For six months in 1943, our father and our family sheltered the Solomon family. Our father was illiterate, and very kind-hearted. He was a baker. The Solomon family consisted of David and Esther Solomon and their children, Matilda and Memo. We now know that Memo's real name was Mori Amarilio Solomon. Esther was a dressmaker. She sewed gold into her dress as a potential source of survival.

This is the neighborhood in Tirana where we lived. It was a very friendly neighborhood, and everyone, including the children, knew we were sheltering a Jewish family. We gave the family Muslim names. Matilda and Memo played with us in the inner courtyard. The father and mother were terror-stricken, but when there were searches our Jewish guests were able to hide by scrambling through connecting doorways to other homes. Those were dangerous times.

Memo became a teacher of music in Beersheba, Israel. He now lives in Jerusalem. Matilda is a businesswoman in Israel.

Our parents were not very religious, but they believed in the Koran and Besa. Without the Koran there is no Besa. Without Besa there is no Koran. For the heart there is no color of skin. No man or woman can forget God.

Beqir Kazazi
Nedred Kazazi
Luljeta Kazazi
Myrvet Kazazi

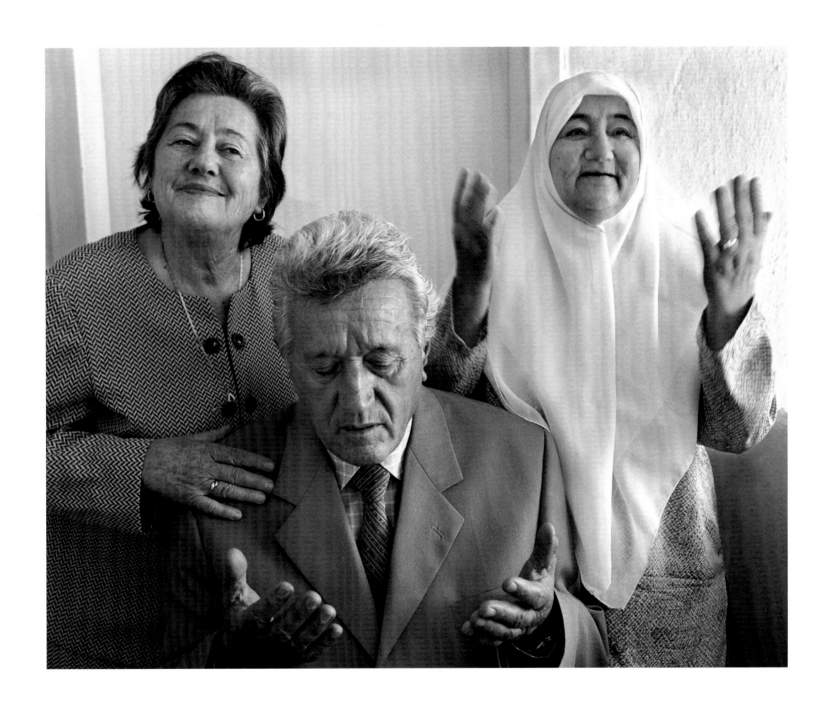

*Nedred, Beqir, and Luljeta Kazazi.*

# Family of Islam Trimi

MY FATHER knew Dr. Ludwig Kalmar, a Jewish physician, and his wife, Jovanka. They were from Hungary originally. Dr. Kalmar was working in a hospital in Tirana. My father had a farm in the village of Shengjergj. When the Germans moved in after the collapse of the Italian fascists, my father gave shelter to the Kalmar family in our farmhouse in Shengjergj. My father took two horses, loaded all their belongings, and walked back eight hours to our farm in Shengjergj.

All the villagers knew that we were sheltering a Jewish family. Our neighbors were sheltering other Jewish families as well. Dr. Kalmar worked as our town doctor for five months. My father often traveled back to Tirana for supplies for the doctor. There was a time when the Germans came into our village looking for partisans and Jews. We dressed the Jewish couple in peasant clothing and they were hidden in a barn outside the village.

In 1945, Dr. Kalmar and his wife returned to the hospital in Tirana and in 1968, the couple moved to Belgrade. Soon thereafter my father died and we lost all contact with the Kalmars.

We also sheltered many Italian soldiers after their capitulation to the Allies. The Germans were killing their former Axis partners. Each family in Shengjergj rescued at least two Italian soldiers. We sheltered five soldiers for thirteen months, until the end of the war.

We Shengjergj villagers have big hearts. It is our tradition. Our village is a righteous Muslim village. We believe that to do good is to get good.

Agim Islam Trimi

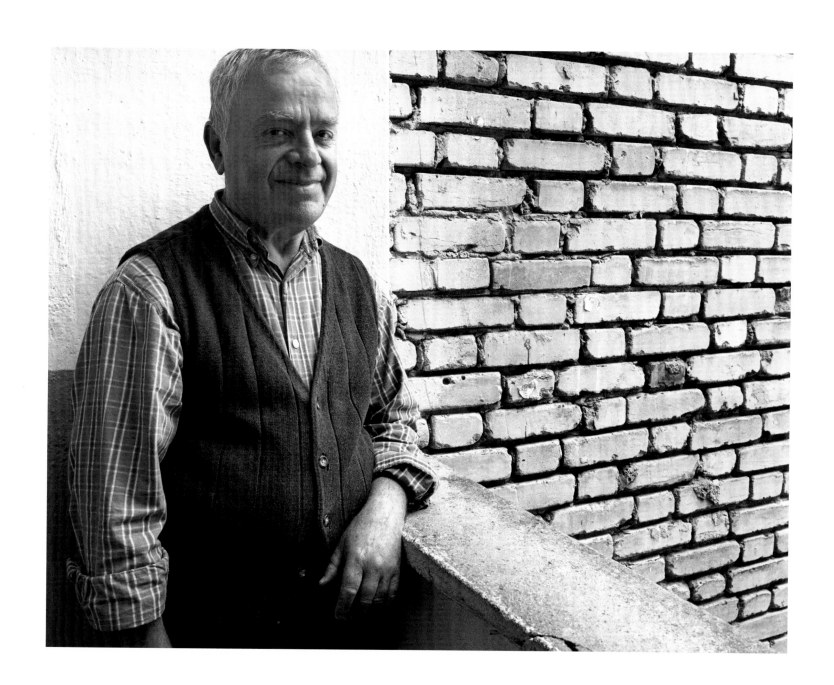

*Agim Islam Trimi.*

# Family of Shaqir and Qamile Borici
# and Their Daughter Bahrije

WHEN I WAS seventeen years old, in 1943, my father brought home Isak and Bela Bivas and their daughter, Rashel, who was fourteen. Isak would come into my father's store for rolls and baking provisions before the German occupation. They were friends. We were told that they would live with us as one family, posing as our relatives from another district. My father organized false passports with Albanian Muslim names. No one was to know they were Jewish. The Nazis had warned our community in Shkoder that anyone harboring Jews would be killed. My father was the burgomaster of our district, and when the Germans demanded to know where Jews were located, my father said he had never heard of Jews in Shkoder. Rashel and I became the best of friends. I taught her the Albanian language, and she even went to religious school with me. She now lives in Israel.

This is the very room in which the Bivas family lived for two years. Almost nothing has been changed in sixty years. Right outside this window is where the German barracks were located. When the Germans conducted searches, the Bivas family hid in our cellar.

Why did we hide our Jewish family? Well, of course we would. We were one family.

Bahrije Seiti Borici

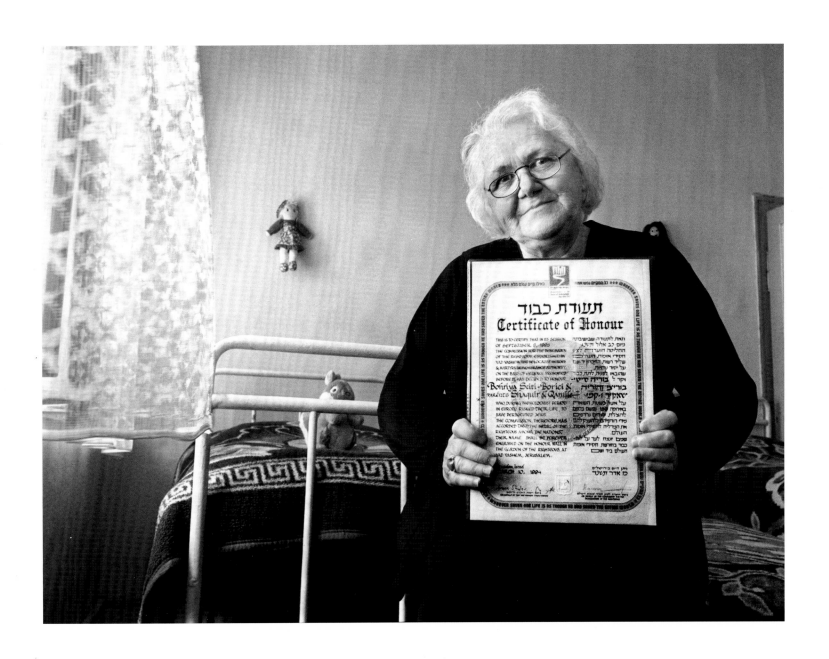

*Bahrije Seiti Borici, holding the Certificate of Honor awarded her family.*

# Family of Ismail Golemi

THERE WAS a large and old Jewish community, called Varosh, in our village of Gjirokaster near the Greek border. Most of the Jewish families were shop owners who had emigrated from Greece early in the twentieth century. Many were relatives of the Batino and Vituli families.

During the reign of King Zog, our father was the chairman of the Nationalist Party in Gjirokaster. We were the first village to be occupied by the Nazis and the first to be liberated. Before the Germans arrived, our father gathered all the Jewish families and made plans for hiding them in surrounding villages. We recall a dinner where the warnings and plans were made. Our Jewish neighbors asked the cost of the proposed hiding, but our father refused any compensation. Despite the warnings, the Jewish families decided to stay in their homes, so our father organized a militia to protect them from the German soldiers. We were fortunate that there were no collaborators among us. If there had been, revenge would have been swift. But all the villagers denied there were any Jews in Gjirokaster.

When several German soldiers temporarily occupied our house, an officer asked a boy named Haim to purchase gifts for his birthday, then became suspicious when Haim did swift calculations regarding the purchases. The German asked if he was a Jew. Haim denied his true identity. We also recall a young Jewish woman named Rochille; when she went to Janina in Greece to get married, the Nazis captured her and her husband. They burned her husband alive and put Rochille in a concentration camp. Rochille escaped, and survived the war in Tirana. In 1945, the entire Jewish community left for Tirana. After communism, many immigrated to Israel.

Our father was a Nationalist commander who fought the Italians, the Nazis, and the communist partisans. He was a member of the Bektashi, as we are. The Bektashi sect of Islam is very liberal. We don't believe in killing. If we find a spider web in our house, we clean out the web but do not kill the spider. After the war, the communists murdered our father. Since the fall of communism our father has been honored as a hero of the resistance. I, Bajram, have written a book about our father.

<div style="text-align: right;">

Gjinovefa Ballo

Bajram Golemi

</div>

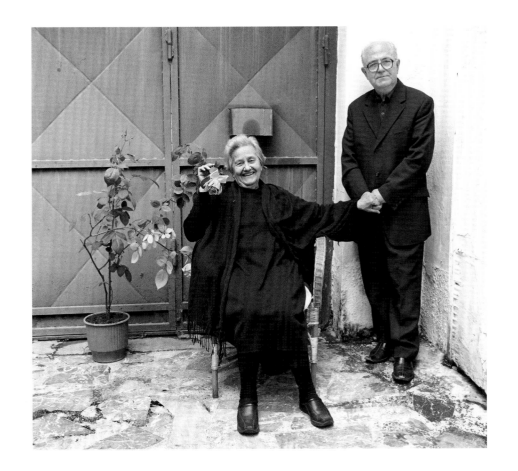

*Gjinovefa Ballo and her brother,*
*Bajram Golemi.*

*Gjinovefa Ballo.*

# Family of Hamid and Xhemal Veseli

OUR PARENTS and our brother, Refik, were the first Albanians to be honored as Righteous Among the Nations by the state of Israel. Now we both have been given the same honor for sheltering the families of Josef Ben Joseph and Moshe Mandil. Both families were refugees from Yugoslavia. Under the Italian occupation Joseph worked for me in my clothing shop and Moshe Mandil worked in Refik's photo shop.

When the German occupation began in 1943, we moved both Jewish families to our family home in Kruje. We dressed them as villagers, and Xhemal walked the parents by night for thirty-six hours to Kruje. Two days later we took the children there. During the day we hid the adults in a cave in the mountains near our village, and the children played with the village children. The entire neighborhood knew we were sheltering Jews; other Jewish families were sheltered by other villagers.

We sheltered the Jews for nine months, until the liberation. Then we lost all contact with the Ben Joseph family. We feared they had left too early for Yugoslavia and were killed by the retreating Germans. The Mandil family returned to Yugoslavia, where Refik visited them after the war and took further photographic lessons from Moshe.

We never took any money from our Jewish guests. Besa exists in every Albanian soul. Our parents were devout Muslims and believed, as we do, that every knock on the door is a welcome from God.

Four times we Albanians opened our doors: first to the Greeks during the famine of World War I, then to the Italian soldiers stranded in our country after their surrender to the Allies, then to the Jews during the German occupation, and most recently to the Albanian refugees fleeing the Serbs from Kosovo. Only the Jews showed their gratitude.

<div align="right">
Hamid Veseli<br>
Xhemal Veseli
</div>

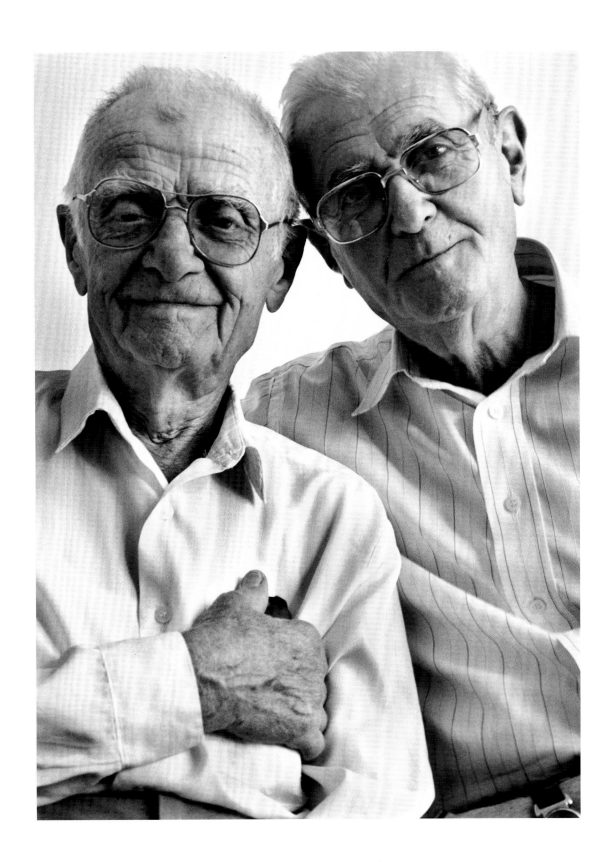

*Hamid and Xhemal Veseli.*

# Family of Vehbi Hasan Hoti

DURING the German occupation in 1944, this house, where I still live, was part of a larger compound. Surrounding us were a German officers' billet, a barracks full of German soldiers, an ammunition dump, and a building housing Italian prisoners of war. Living among the Germans was terrifying.

I was seven years old. We were sheltering a Jewish girl in our home. She was eighteen, and her name was Rashela Kutjel. Two of her sisters were hidden in other homes of our family, both also in Shkoder. Her parents and one of her sisters were sheltered in the village of Krebe. The whole family had escaped from Nazi detention in Pristina. The Nazis had questioned the daughters separately from their parents and threatened to kill them all in an attempt to extort their gold.

When Rashela lived with us, she dressed as a Muslim. She became a daughter to our parents and a sister to us. One day Rashela saw one of her Nazi captors from Pristina and sobbed from the fear of being recognized.

When the war ended in 1945, Rashela left with her sisters and parents for Israel. An iron curtain then descended on Albania and we lost contact for fifty years. In 1995, with the help of another Righteous person, Drita Veseli, we made contact with Rashela. In 1998, I traveled to Israel to be reunited with Rashela. I also met her two sons and her grandchild.

Our entire family are devout Muslims.

Vehbi H. Hoti

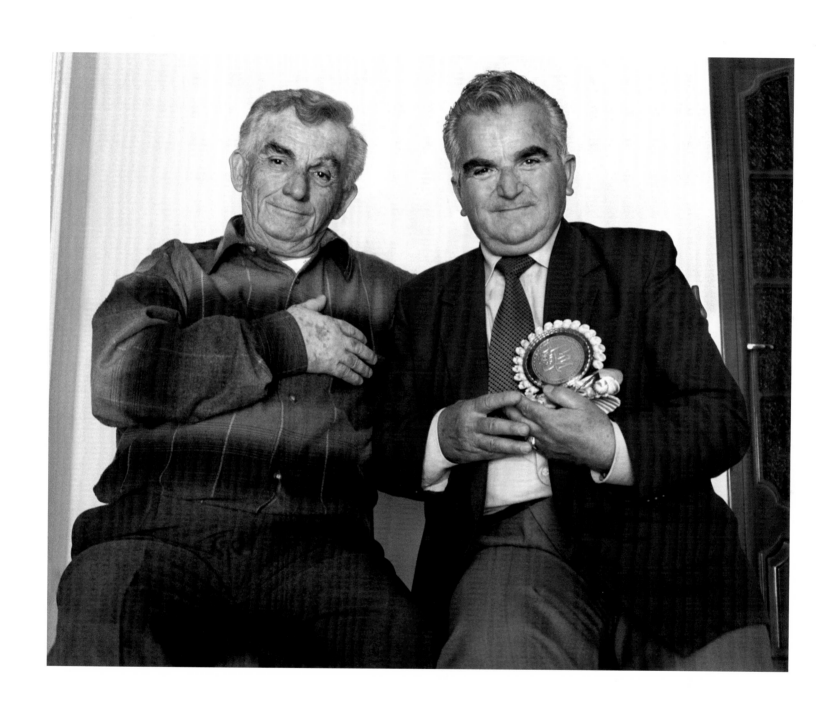

*Celja and Vehbi Hoti.*

# Family of Ali Sheqer Pashkaj

OUR TRADITIONAL HOME is in Puke. My father owned a general store with food provisions. It was the only store of its kind for many miles around. One day a German transport rolled by with nineteen Albanian prisoners on their way to hard labor, and one Jew who was to be shot. My father spoke excellent German and invited the Nazis into his store and offered them food and wine. He plied them with wine until they became drunk. Meanwhile he hid a note in a piece of melon and gave it to the young Jew. It instructed him to jump out and flee into the woods to a designated place.

The Nazis were furious over the escape, but my father claimed innocence. They brought my father into the village and lined him up against a wall to extract information about where the Jew was hiding. Four times they put a gun to his head. They came back and threatened to burn the village down if my father didn't confess. My father held out, and finally they left. My father retrieved the man from the forest and hid him for two years in his home until the war was over. His name was Yasha Bayuhovio. There were thirty families in this village, but no one knew that my father was sheltering a Jew. Yasha is still alive. He is a dentist and lives in Mexico.

Why did my father save a stranger at the risk of his life and the entire village? My father was a devout Muslim. He believed that to save one life is to enter paradise.

<div align="right">Enver Alia Sheqer</div>

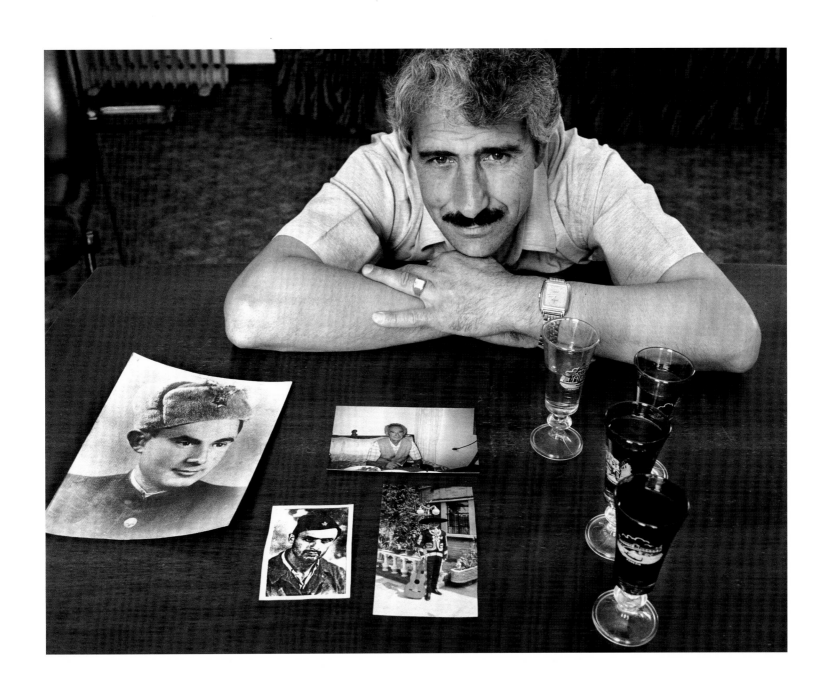

*Enver Alia Sheqer, with family photographs.*

# Family of Beqir Qoqja

I AM ninety-one years old and in good health. I live in the same house now, with my son and his family, as I did when I sheltered my close Jewish friend, Avram Eliasaf Gani, in 1943 and 1944. At first I hid Avram here, but when the persecution of Jews became more horrible, I sent him to the home of my parents in a remote district of Kruje. There were no roads for cars back then, so each week until the end of the war I traveled on horseback to my parents' home to provide food and all necessities for my friend. During those years, no one except my family knew of our sheltering a Jew. After the war, Avram returned to Tirana and we remained good friends.

I have been a tailor all my life. Now I am retired and everyone calls me Baba, meaning "Father." I still like to dress with style.

I have always been a devout Muslim. During the years of communism all the institutions of God were closed, but not the heart. I did nothing special. All Jews are our brothers.

Beqir Qoqja

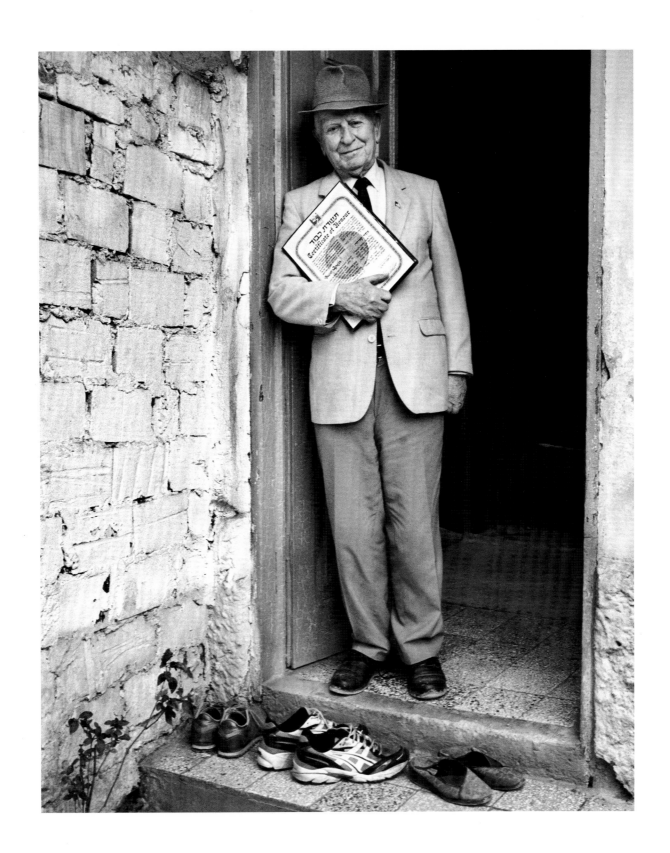

*Beqir Qoqja, holding his Certificate of Honor.*

# *Rezniqi Family*

MY FATHER Asllan and I were traders in many commodities. Our ancestral home is in Decani, Kosovo. I was seventeen years old in 1941. My sister and I were both dying of typhus. A Jewish doctor—a partisan named Chaim Abrovonel—provided medicine for us and we survived. The Germans near our village subsequently captured Chaim's military unit. With a Jewish friend, Solomon Comforti, my father helped Chaim escape and sheltered him in our home for several months until he could return to his home in Skopje, Macedonia. In late 1941, the Germans moved into Skopje, and the Jews fled. We built a stone house behind our house to shelter our Jewish friends from Skopje. We sheltered the three Comforti brothers and their families, the families of Samuel Misrahi, and the David Cohen Levy family. We changed Dr. Abrovonel's name to Hamid, and he became our village doctor. The entire village knew we were sheltering Jews.

Our home was also a way station for about thirty other Jewish families from Macedonia and Serbia. I was the commander of the partisan unit in my village. In Pristina there was a camp for Jewish refugees and we partisans rescued many from the camp. In early 1943, Albania was still under the Italians and closer to what we thought was freedom, so we escorted the families to Albania. But in late 1943, they all went into hiding when the Germans occupied Albania.

At the end of the war most of our Jewish friends returned to their homes in Skopje and then went on to Argentina, Italy, Greece, and Israel. Dr. Abrovonel immigrated to Israel. He has passed away, but I believe a niece of his survives in Israel.

In 1999, the invading Serbs destroyed our ancestral home in Decani. My son and I are holding the Albanian flag as a symbol of our dream of a new nation with strong ties to our brothers in Albania and free of Serbian oppression.

It is written in the Koran to help those who need help. In our family we respected all religions. We respected our Jewish neighbors with friendship and humanism.

I am now forming a Kosovo Israeli Friendship Association. Many have asked me to create this organization in remembrance of those times.

<div align="right">Mustafa Rezniqi</div>

[In 2008, Asllan Rezniqi was recognized by Yad Vashem as Righteous Among the Nations. N.H.G.]

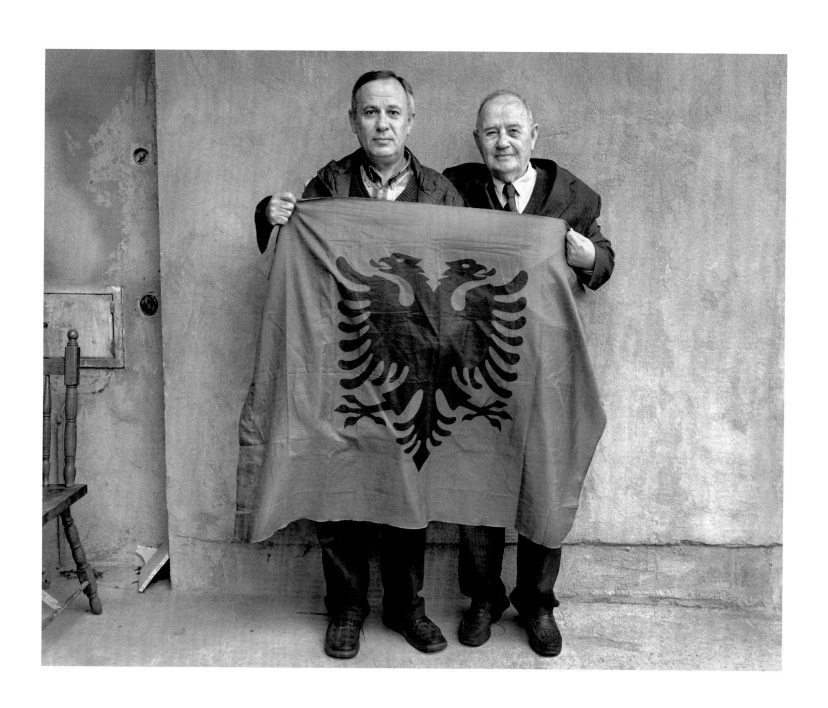

*Mustafa Rezniqi, right, and his son, holding the Albanian flag.*

# Family of Hasan Reme Xerxa

THIS IS our family home in Gjakove, Kosovo. We were traders of food and clothing. We had many Jewish friends, also traders, from Skopje in Macedonia. We were all in business together. We were all great friends. Before the German occupation, Skopje was a major trading center with a thriving Jewish community.

When the occupation began, I sent cars to Skopje to rescue our Jewish friends and their families. There were so many. I remember the families of Raphael Nathan, David Cohen, Solomon Comforti, and Maurice Israel. I moved them first to Decani, where they were sheltered by the Rezniqi family, and finally to Tirana in Albania. We used our own transport and even paid for the gasoline. Why not? These people were no strangers.

I also remember a Jewish factory owner from Warsaw who claimed to be the richest man in Warsaw. He carried with him antique tapestries. We moved him by car to Tirana.

I am now eighty-nine years old. I have outlived the Italian, German, Yugoslav, and Serbian occupations of Kosovo. I know prisons. In 1943, the Germans detained me for six months. I paid a bribe of one thousand gold coins for a pair of boots and my freedom.

When the war ended in 1945, I was arrested as a nationalist by Tito's communist regime. I spent fifteen years in prison, including two years in solitary confinement. I hauled stones on my back. All our property was taken away. In prison I became friendly with three Jews. They were given the opportunity to go to Israel. One was a rabbi who gave me these prayer beads when he left. If you hold them up to the light you can see a flower in each bead. These beads kept me alive during the long years of confinement. They are precious to me.

In 1999, we suffered the occupation of the Serbs. They took our home as their headquarters until the NATO forces pushed them out. Our property was then returned to us.

I took nothing from the Jewish people we rescued. How could I not save Jews? I felt their suffering. I never lost faith as a Muslim and I never lost faith in the tradition of Besa. First is my nation and then my religion. I can always change my religion, but not my nation.

<div align="right">Hasan Reme Xerxa</div>

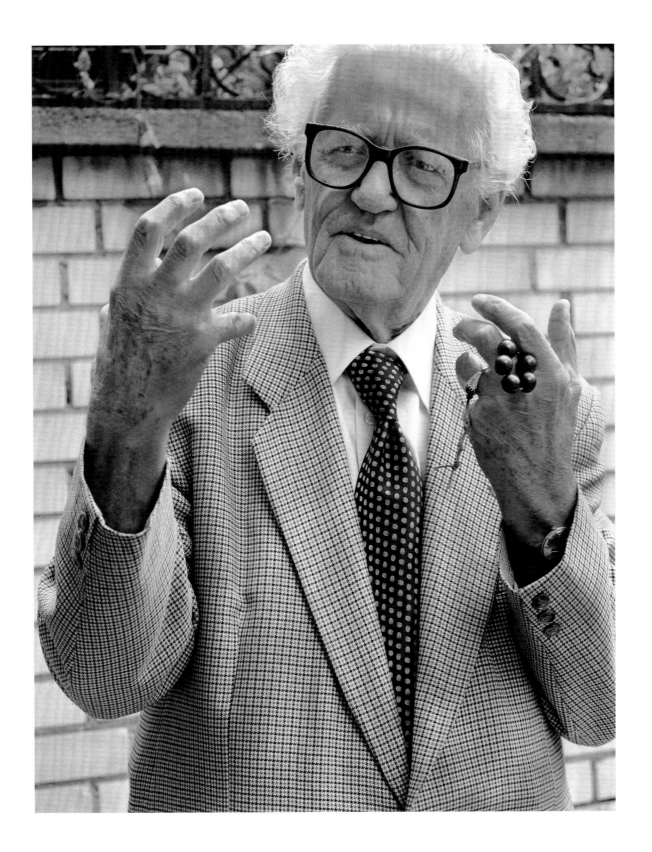

*Hasan Reme Xerxa holding his prayer beads.*

# Family of Ramadan and Isa Nuza

OUR HOME was on the outskirts of Gjakove, Kosovo. It was considered safe from Nazi patrols. During the German occupation a friend asked us to shelter two Jewish families who were in great danger. They were refugees escaping from the village of Prizren, and were originally from Skopje in Macedonia.

The Jewish families had assumed Albanian names. There was Hamdi, his wife Ajshe, and their daughter. From the second family we can recall only the name Esop. To this day we do not know their real names. We never asked. We knew that they were traders in Skopje. We sheltered them for ten months and then moved them to a safer area thirty kilometers from Gjakove. We supported both families and accepted no money from them. After liberation both families came back to Gjakove to express their gratitude to us. We all celebrated. Then we hired a truck and drove them back to Skopje. After that we lost all contact.

It is an Albanian tradition, then and now, always to have our door open for guests. The next time it could be our family needing shelter.

We are religious Muslims and say our prayers in Arabic.

Ramadan Nuza
Isa Nuza

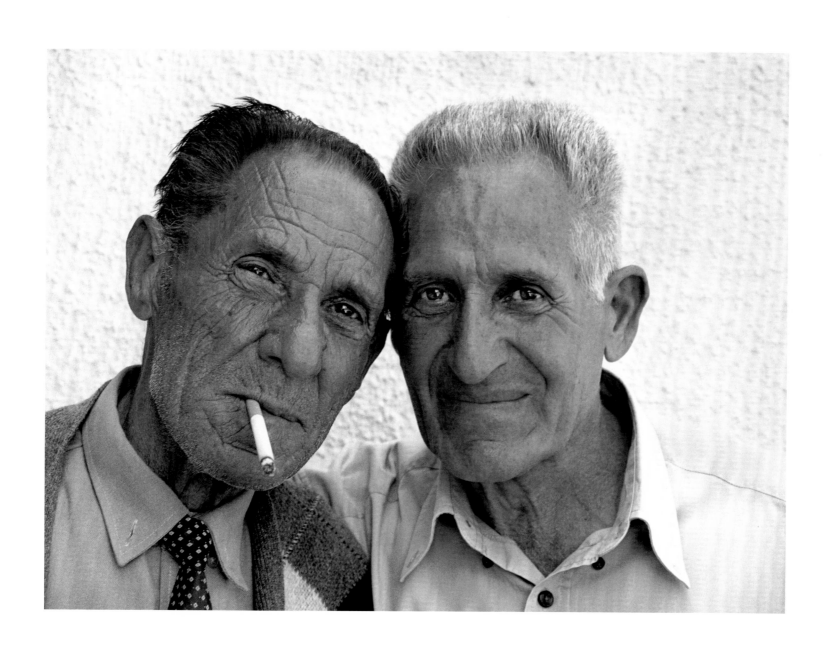

*Ramadan and Isa Nuza.*

# Family of Mullah Shabani

IN 1942, I was a young girl of five when we sheltered a Jewish family from Skopje in Macedonia. The group included Simon Ibrahim, a trader and a good friend of my father's, his sister Mara, and a young boy who was their friend. Their room was on the second floor of this house, still our family home, in Gjakove, Kosovo. They stayed with us many months. I remember how afraid they were. They came out of the room only at night. We told no one in our village that we were sheltering Jews.

One day we learned that an informer had tipped off the Germans that there were Jews in the village. We immediately provided horses, and the three Jews escaped, wearing peasant clothes. They went to the village of Banje, where my uncle Miftar provided for them. That very same day, a German search party came to our home looking for the Jews. They found nothing.

We know that all three survived the war, but then we lost contact. I know that the youngest became a civilian pilot in Albania. I do not remember his name.

My parents were devout Muslims. We have been Muslims for three hundred years. My grandfather, Shoban, was a mullah. My parents were just doing the right thing in sheltering the Jews. It was justice. My father was a good man, a very good man.

Ikball Shabani

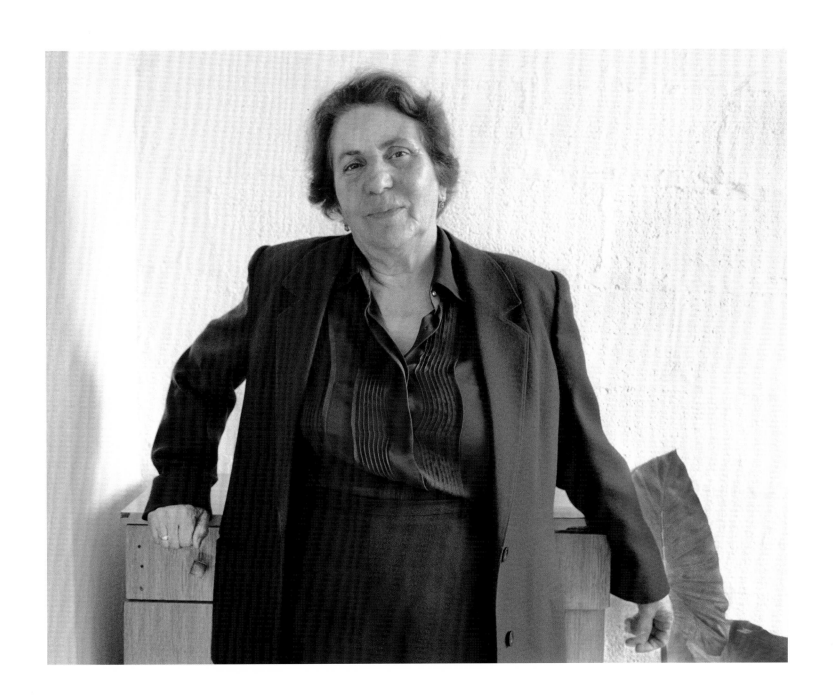

*Ikball Shabani.*

# Family of Basri Hasani

I DO NOT remember my parents. I am an orphan. I have lived all my life in Mitrovica, Kosovo, and have been the city administrator for many years. Our town is known as Red Mitrovica because we have seen so much bloodshed. We suffered under the Nazis from 1941 to 1945, then experienced the Serb ethnic cleansing and NATO bombing in 1998 and 1999. I lived through it all. I know the history and suffering of the families, and especially of the Jews.

Before the war Mitrovica had eleven thousand inhabitants—Turks, Serbs, Jews, and Albanians. All citizens worked together and respected the individuality of all.

The Rubenovic brothers were my next-door neighbors. There were Rakamin, Aron, and my best friend, Moshe. Moshe's uncle was the rabbi of Mitrovica. The Jewish families of our town were religious and prayed at the synagogue. Most of the Jews were traders.

In 1941, the Germans occupied our town. Rakamin's shop was closed. The prefect of Mitrovica organized an escape for the Jews. They were hidden in surrounding mountain villages. We also helped to shelter Italian soldiers, whom the Germans were killing.

The Nazis captured both Rakamin's and Aron's families. We never heard from them again. Moshe joined the partisans in 1941, and fought the Nazis throughout Albania and Kosovo. He came back as a captain of the partisans and I sheltered him in my home while he and his band fought the Nazis in our town.

In 1945, Moshe left for Israel; later, I think, he settled in America. I don't really know as I have lost all contact with my friend. Forgive my tears, but Moshe was such a good friend during those years. I long to be reunited with him.

I do not go to the mosque, but I am a true Muslim. The Holy Koran is in my genes. I say my prayers each evening. My door is always open to anyone in need.

Basri Hasani

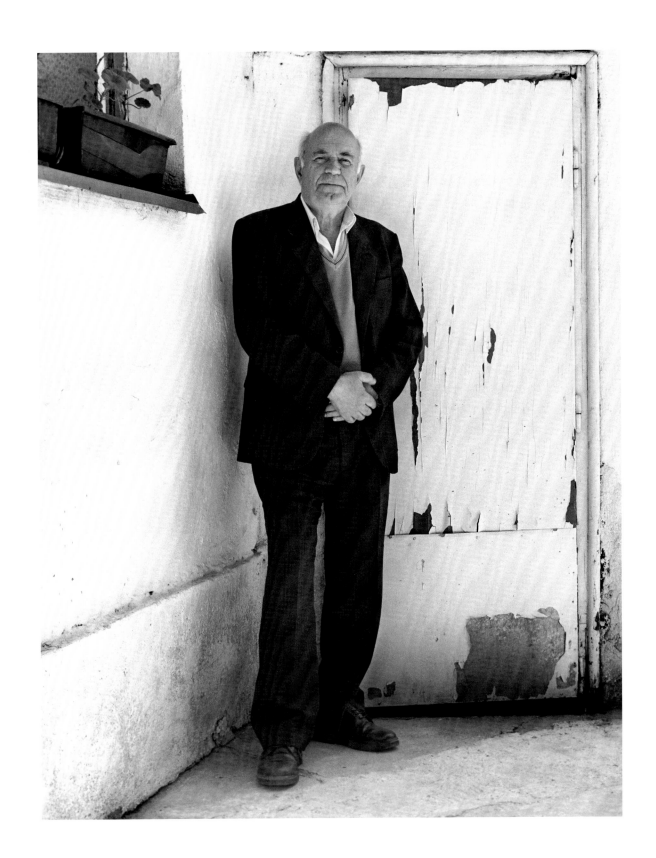

*Basri Hasani.*

# Family of Sadik Behluli and Son Ruzhdi

WE LIVED in the small village of Novosel in Kosovo. My father owned a pastry shop. Our entire family fought against the Italians, the Bulgarian fascists, and the Germans. The Bulgarians jailed me in 1941, when I was twenty years old. It was easy to bribe them with a chicken, and I was released.

In 1942, a prisoner train from Serbia came through our region. Chaim Cohen escaped with seventy-two other Jews into the mountains near our village. We sheltered Chaim in our home when he sought asylum. At first we found it strange that he never took off his clothing. He even slept in his clothing. It was because Chaim had sewn gold coins into his garments. We assured him that no one in our family would steal from him. We then dressed Chaim as a woman in traditional Muslim clothing, including a veil. After three weeks we sent him to my sister's house, where her father-in-law provided him with false Albanian papers. My father then walked Chaim to the Albanian border.

We know that he spent three years in Elbasan, Albania, and opened a textile shop. After the war he lived in several countries in South America, then moved to Italy, Israel, Serbia, and finally to Brazil. We know all this because Chaim visited us with gifts, first in 1957 and then again in 1981. We also were privileged to meet his family on his second visit.

Under the communists our family suffered. My father, as a nationalist, was condemned to death, although his sentence was later commuted to ten years in prison.

Our family are Albanian nationalists and devout Muslims. It was through the Koran and Besa that we felt the courage to shelter Chaim. No one in our village knew. We acted from our hearts.

Ruzhdi Behluli

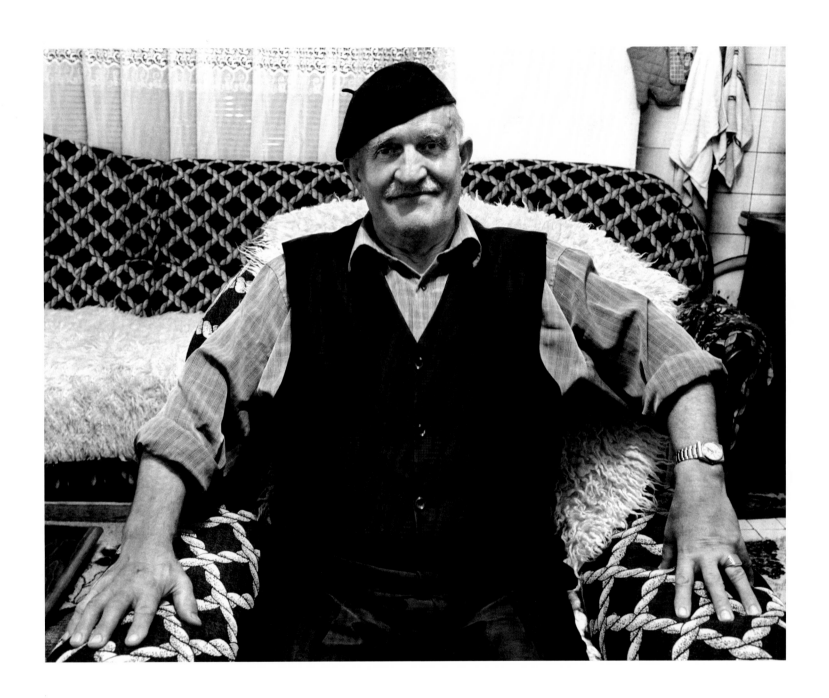

*Ruzhdi Behluli.*

# Family of Sejdi Sylejmani

I AM eighty-three years old. As you can see, I lost my hearing during the NATO bombing in 1998, but I am grateful that they forced the Serbian invaders from our city.

I remember well the years 1937 through 1943. Our city of Mitrovica in Kosovo had a diverse ethnic citizenry. There were Jews, Turks, Albanians, and Serbs, and all got along quite well. Mitrovica was a family. We spoke Turkish, Albanian, and some Arabic. Many Jewish families were shop owners and traders. The Jewish shops were the best for quality and honesty.

In 1943, everything changed in Mitrovica when the Germans stationed troops in our city. The Germans closed all of our shops, and our Jewish citizens were in particular danger. Our living conditions were terrible, and we depended on remote villagers to sneak into Mitrovica at night to sell us food.

I had a Jewish friend named Joseph who used to give cigarettes to my uncle, Adil Sylejmani, during Ramadan. There were also two Jewish doctors named Dr. Shenfana and Dr. Raphael Piad. We dressed our Jewish friends in Albanian costumes and had them sheltered in small villages in the mountains outside of Mitrovica. We sheltered Joseph, his wife, two daughters, and son with my uncle Adil and gave them food in the evening when they came down from hiding in the mountains. We also sheltered a Serbian family. We organized safe transfers of many of our Jewish citizens to Albania from their shelters in the villages surrounding Mitrovica.

Our motivations were not religious. We respected our Jewish friends. They were honorable citizens just like us. Whatever we could do for them in those times, we did.

Sejdi Sylejmani

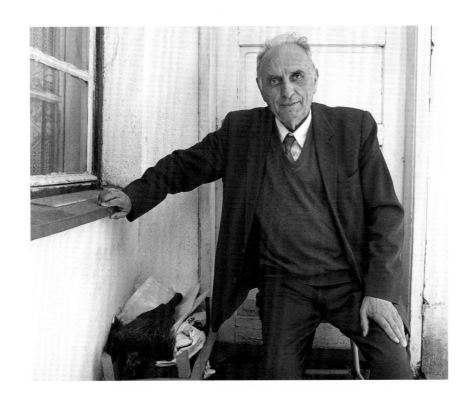

*Sejdi Sylejmani.*

# Family of Jusuf Sadik Mimonaj

I WAS BORN in 1921. All my life I have been a nationalist. I served under King Zog. All my sons and daughters are nationalists.

A cousin of mine brought a Jewish family of six to my home in Prokolluk, Kosovo, in the summer of 1943. We sheltered them until the spring of 1944. I cannot remember all of their names. There was the elderly father, Avrom, his wife, two daughters, and a son, Emine, with his wife. Avrom was a grain trader, I believe, from Skopje, Macedonia. We ate our meals as one family. I recall the Jewish family reading the Koran. They were afraid to practice their religion openly, but secretly they said their prayers in Hebrew.

Avrom had a daughter in Albania and two other sons hiding in Montenegro. He was very concerned about whether his daughter was still alive. I drove a truck over the minefield-laden mountains to Albania to look for her. It was very dangerous. First I went to Shkoder and then to Tirana, where I found her attending a wedding. She was overjoyed to hear her family was being sheltered. I then returned to Prokolluk to give the good news to Avrom. It was I who escorted Avrom and his family back to Albania in 1944. After the war, Avrom visited us in Prokolluk. That was our last contact.

We are secular Muslims and proud nationalists. The Serbs burned down our home in 1999 and arrested my sons, Mirsat and Sadit. We had to flee to Lezhe in Albania. Yes, we are Muslims. But the religion of Albania is Albania.

<div align="right">

Jusuf Sadik Mimonaj
Mirsat and Sadit Mimonaj

</div>

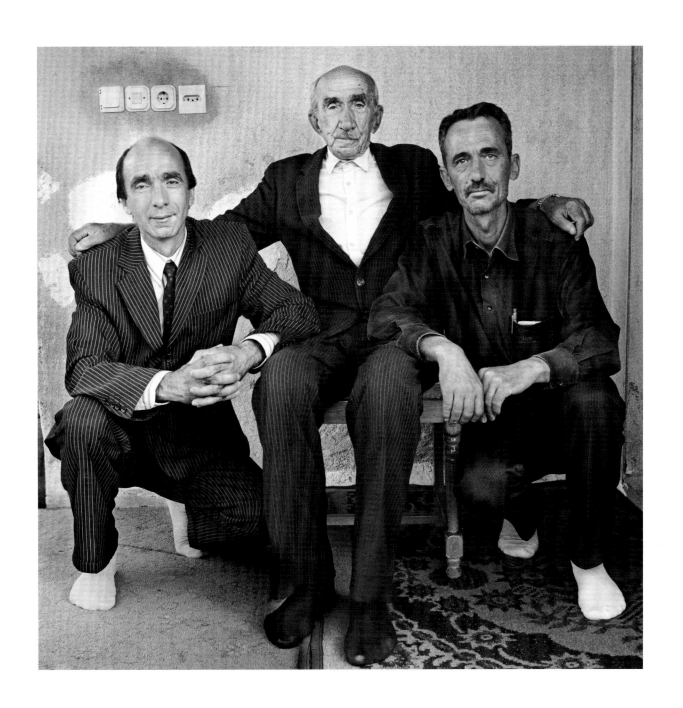

*Jusuf Sadik Mimonaj, center, with sons Mirsat and Sadit.*

# Family of Hysni Domi

OUR VILLAGE of Gjakove, Kosovo, is small and everyone always knew everyone. In 1937, David Levy came to our village from Switzerland with his wife, Laura, and son, Mario. David worked with our uncle Rasim as a tradesman and also managed a mine. Even when the Italian occupiers conscripted the mine, David continued to manage the business. There were other Jewish families living and working in Gjakove without any discrimination, even under the Italians. All were citizens of Yugoslavia.

But the situation changed radically when the Germans began their occupation of Kosovo in 1943. Jews were no longer citizens. They were hunted down and deported or killed.

The Levy family planned to flee from the Nazis, who were coming from the north. David Levy came to our father for help. They were the best of friends. David gave our father a large package of precious jewelry for safekeeping. Our father insisted on writing out a receipt; he kept one copy and gave a copy to David in the hope that our families would be reunited.

Unfortunately, the Nazis captured the Levy family. David and Mario were deported to a death camp in Austria. They were both killed there in 1944, when the Allies bombed the camp. We learned this from a surviving relative of David's. Laura was deported to a camp in Germany and survived. She returned to Gjakove in 1945. Her health was broken and she was destitute. She knew nothing of the valuables kept by our father. She was overjoyed and tearful when our father showed her the receipt and jewelry. She insisted that he was entitled to half of the treasure, but our father refused. He had given David his word and his Besa. Finally our father accepted a small diamond ring and gave the valuables back to Laura. Soon after, Laura left Gjakove. We think she went to Switzerland, but we lost all contact.

We are the proud sons of Hysni Domi. He left us a legacy of honesty and decency to all mankind. Our father prayed in Arabic and lived his religion. This is the ring given to our father by Laura Levy. It is our family treasure.

Ruzhdi Domi
Shkelzen Domi
Bujar Domi

*Hands of Ruzhdi, Shkelzen, and Bujar Domi, holding the ring given them in gratitude.*

# Family of Pjeter Jankovic

IN THE LATE 1930s, Pjeter Jankovic traveled to Canada, where he worked in a coal mine. It was there that he met several Jewish friends. Friendship for Pjeter was a sacred matter. In late 1940, Pjeter returned to his village of Ftjan, Montenegro.

In 1944, Serbian partisans forced many Montenegrins and Jewish refugees to fight the Nazis. More than five thousand forced recruits escaped into the mountains. One day when Pjeter was traveling to his village, he came upon a young Jewish escaped prisoner by the name of Mehmet, who came from Kosovo. Pjeter gave Mehmet bread and offered him asylum in his home in Ftjan. The hills were filled with escaping prisoners and Jews on the run, and collaborators hunting and killing the Jews. It was dangerous to travel together, so each night, from hilltop to hilltop, they made contact with whistles. In Ftjan, Mehmet was sheltered for a year in Pjeter's barn and took care of the sheep. Mehmet built a new barn as well as a stone wall. The people in the village called the barn Mehmet's barn. During the day Mehmet appeared as a Muslim, but he secretly prayed as a Jew. In 1945, Mehmet dressed as a woman and left for Shkoder in Albania; Ftjan was very near the border with Albania. All contact then was lost. In 1979, an earthquake destroyed Ftjan and the village was abandoned. All that was left was the stone wall built by Mehmet.

I was a boy in Ftjan in 1968, when Pjeter Jankovic told me this story, just before he died. I gave a promise to Pjeter that I would remember what he told me. Now I have fulfilled that promise.

Gjergj Pepgjonaj

*Gjergj Pepgjonaj.*

*Bunkers (pillboxes) in Albania.*

# Afterword

## On and Off the Road in Albania and Kosovo

NOT MANY TRAVEL AGENTS know the routes to Albania and Kosovo, much less where they are. To prepare for my first trip in 2004, I sought travel brochures and found none. I was told that only returning Albanians travel to Albania. The country still suffers from the aftermath of fifty years of ruthless post–World War II communism.

There are sad monuments everywhere in Albania to its communist past. Approximately five hundred thousand decaying pillbox bunkers dot the countryside and coastline, the cities and villages. During the long communist period, soldiers guarding the homeland from imagined imminent invasion had manned these concrete bunkers—but no one could identify the expected enemy. The enemy could be from within. Imams and priests were incarcerated, as were such "enemies of the state" as shop owners, body builders, men with beards, and those learning a foreign language. Since my initial trip, I have returned often to visit and record stories of the children, and, in rare cases, a surviving parent of this turbulent time.

When we visited these families, we were greeted with nuts, fruit, candy, *raki* (the national drink), and above all, with warmth. No one spoke English. I traveled with a driver, an interpreter, a guide from the Albanian Israeli Friendship Association, and my associate, Stuart Huck.

It seemed that the more difficult it was to reach a rescuer's home, the better the stories and portraits. Our car could not make it to the home of Lime Balla. The steep, boulder-strewn incline was too much for our vehicle and driver. We stopped and trudged up hills with our equipment for what seemed like a mile or more. Reaching Kasem Jakup Kocerri was no better: no address and a single rocky road way out of town. The road was so narrow we couldn't have turned back even if we'd wanted to.

I recall visiting the home of Beqir Qoqja. His son greeted us at the door, invited us in, and proceeded to tell the story of his father's rescue of Avram Eliasaf Gani. I assumed that Beqir had passed away. Then a door opened, and there he was. It was a grand entrance! Beqir was handsomely dressed, with shirt, tie, jacket, and a fedora rakishly tipped at an angle. Now in his nineties, Beqir continued the story.

The contrasts in postcommunist Albania are particularly exemplified by the food. We were sitting in a restaurant near the Adriatic Sea. Restaurants are still very much a luxury, and this empty place was no exception. All the menus are in Albanian, and our host, through an interpreter, recommended the local fish. I noticed that there were three different prices for the same fish, from most expensive to least. I asked the waiter, through our interpreter, why the difference

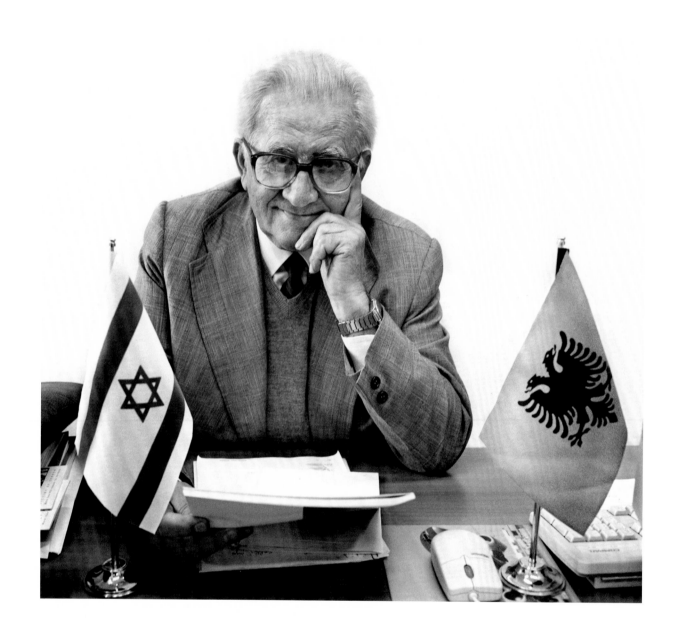

*Professor Apostol Kotani of the Albanian Israeli Friendship Association.*

in price for the very same fish? Well, one fish is fresh, the second not so fresh and the third has been around awhile!

All was not lost: soon we were treated to a wonderful, traditional Albanian home-cooked meal at the home of Professor Apostol Kotani. His wife served us from the kitchen while we men all sat together at the table. We each left with a gift of an aromatic fresh herb in our hands in remembrance of a fine Albanian meal.

In the early years, traveling the roads was more like moving through bombed-out craters, particularly on the outskirts of Tirana, Albania's capital. One day, we were advised to drive over the mountains from Tirana to Pristina, the capital of Kosovo. It was to be a calm and enjoyable three- to four-hour sightseeing trip. Twelve hours later, on a hair-raising, tortuous mountain road with no guardrails, we reached the border of Kosovo. But our driver had an out-of-date passport, and after perhaps an hour of screaming and ranting by our interpreter, demanding that we be allowed into Kosovo, we unloaded our baggage and hired the cousin of the Kosovo border guard to take us to Pristina.

The Lonely Planet guide described our hotel in Pristina as a five-star hotel minus three stars! Our guidebook was correct. We crashed into the hotel after midnight and collapsed into our broken-springed beds only to be awakened by a series of loud beeps at regular intervals. The noise seemed to be coming from outside my window. The regular beeping was maddening. Thinking it might be a fire alarm, I called the front desk. I was told that the beeping was for blind pedestrians crossing the wide avenue in front of the hotel. I quickly changed rooms to escape from the beeping and again collapsed into a broken-springed bed.

In retrospect it was all worth it: the harder it was to get to some of these places, the more rewarding the results.

<div align="right">Norman H. Gershman</div>

NORMAN H. GERSHMAN is a photographer whose work is represented in numerous museums and private collections throughout the world, including the International Center of Photography, the Brooklyn Museum, the Aspen Art Museum, Rizzoli, and several venues in Russia. In Israel, his works are represented in the permanent collections of the Museum of the Jewish Diaspora in Tel Aviv and Yad Voshen in Jerusalem.

In his early years Gershman studied with many of the great photographers, ultimately honing his own style and mounting many exhibits. Gershman's photographs are purposeful. Virtually all of his work is done with available light; to quote the legendary photographer Eugene Smith, he uses any light that is available.

His work can best be defined as humanistic rather than journalistic. In creating portraits, Gershman photographs with his heart, seeking to capture his subject's soul, usually through eye contact. His ability to engage his subject on an intimate level through his camera has allowed his portraits to pass through the veil of anonymity and give back to the recipients themselves. His work in the Soviet Union and Cuba, and, most recently, his four-year project to recall and celebrate Muslim families in Albania who saved Jews in World War II, has brought people together. Among the international leaders and scholars who have praised his work are former Israeli prime minister Yitzhak Shamir; former U.S. president Jimmy Carter; Madam Jehan Sadat; congressman Tom Lantos; Dr. Mordecai Paldiel, former director of the Righteous Among the Nations Department of Yad Vashem; Noble Laureate Elie Wiesel; Dr. Akbar Ahmed of American University in Washington, D.C.; and Cornell Capa, founder and Chairman Emeritus of the International Center of Photography.

In addition, Gershman also has worked as a collector and dealer of fine art photography and has lectured, written, and published extensively on photography.

*Norman H. Gershman.*

A documentary film, *God's House: Muslims Who Saved Jews in World War II*, is currently in production. A photographic exhibition, Besa, A Code of Honor: Muslim Albanians Who Rescued Jews During the Holocaust, premiered at Yad Vashem in Jerusalem in November 2007. In January 2008, the exhibition began a worldwide tour, under Yad Vashem's auspices, at the United Nations in New York.